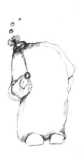

A Gail Prussky Book

The Secret Life of
DORIS MELNICK

GAIL PRUSSKY

Introduced by
David Cronenberg

Final Words by
Terry Graff

EXILE
editions

singular fiction, poetry, nonfiction, translation, drama, and graphic books

Library and Archives Canada Cataloguing in Publication

Title: The secret life of Doris Melnick / Gail Prussky ; introduced by David Cronenberg ;
final words by Terry Graff.
Names: Prussky, Gail, author. | Cronenberg, David, 1943- writer of introduction. |
Graff, Terry, writer of afterword.
Identifiers: Canadiana (print) 20200279734 | Canadiana (ebook) 2020028052X |
ISBN 9781550968934 (softcover) | ISBN 9781550968941 (EPUB) | ISBN 9781550968958 (Kindle) |
ISBN 9781550968965 (PDF)
Classification: LCC PS8631.R87 S43 2020 | DDC C813/.6—dc23

Published by Exile Editions ~ www.ExileEditions.com
144483 Southgate Road 14 – GD, Holstein, Ontario, N0G 2A0
Printed and Bound in Canada by Marquis

We gratefully acknowledge the Canada Council for the Arts, the Government of Canada,
the Ontario Arts Council, and Ontario Creates for their support toward our publishing activities.

Canadian Sales: The Canadian Manda Group, 664 Annette Street,
Toronto ON M6S 2C8 www.mandagroup.com 416 516 0911

North American and international distribution, and U.S. sales:
Independent Publishers Group, 814 North Franklin Street,
Chicago IL 60610 www.ipgbook.com toll free: 1 800 888 4741

for Mr. Sniderman,

my grade four teacher who, when he saw my drawing of a wolverine devouring a small child said "That's GREAT, Gail! Keep going!"

Mr. Sniderman...I kept going.

Thank you for not stomping out the crazy when I was a small child.

Contents

A Grackle in the Darkness
by David Cronenberg

The darkness is in the basement, of course. Where else would it be? And it's difficult to see the darkness, even with prism glasses, because it's in the nature of darkness not to be seen. Yet, despite this unseeingness, the basement is a place of refuge, of safety, until it fills with sea water, and becomes the ocean, and the ocean is full of disgusting, slimy, evil things, and so there is no more refuge in the basement. You can try to empty the basement of sea water by using that soup ladle, but the task is ultimately futile, and the ladle turns against you, and leaves you bruised and humbled.

And so, eyes blinking, you emerge from the basement into the pale, flickering light of FoodWorld, which, for you, is RealWorld, where you are an anonymous cashier. But those eyes! Those eyes were not made for depth perception. Those eyes are disjointed eyes, schizophrenic eyes, each eye delivering a different reality. You have created the eyes belonging to your creatures, bulging on stalks, pointing in different directions, intensely soulful and sinister, hopeful and guileless. Predatory. Rapacious.

And vengeful. Oh yes.

And despite the RealWorld diagnosis of double vision, you realize now that their eyes, the monsters' eyes, are your eyes. There are no corrective lenses for the kind of vision you have.

Underneath FoodWorld lies another, unnamed world – a teeming, chaotic hothouse world with no mercy, no beauty that is not deformed, and no humanity that is not compromised by bodies out of control. Like your own body. Yes, your body, dear. The one co-workers describe as very fat with big feet, topped by a plain, flat face, a pie face. Hair in the same knob for 30 years. Sweats when it's anxious. Upper arms flapping like fleshy wings. Fuelled by hard-boiled eggs and beans.

So it is not only their eyes that belong to you. All those other squirming, twisting, tormented body parts are yours too. You say drawing these bodies entertains you, sustains you, exacts vengeance for you on the cats that you hate, on Betty in the deli department. But I say these are self portraits, all of them, they are all you right down to the cellular level, you are recording the struggles within your corporeal cells, those cells that are hungry for recognition, for nourishment, for love. This book is the *Gray's Anatomy* of one body.

When the sun goes down, I want to vomit. The feeling doesn't last long, but it is powerful, disturbing. I'm pretty sure it has to do with death, with the coming of that inexorable, all-enveloping basement darkness. And with the loss of that love you were always so desperate for, embodied by Duane, meticulously stacking turnips and Honeycrisp apples, but unworthy of your remarkable, grotesquely exquisite love. Night. Loveless night. If only I had known you.

Are you really dead now, dead in your little bed in your immaculate bungalow? It's possible that you are not dead, that you have simply returned to the darkness of the basement, like that bird, the grackle, which disappears in the darkness. But this book is the light that finds you, reaches you wherever you are, the light that brings out your colours, feathers flashing blues and purples. Doris. Melnick.

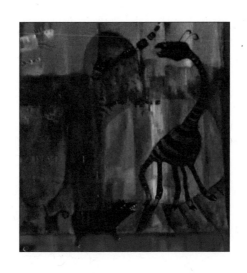

The Secret Life of Doris Melnick
by Lucille Melnick

A few months ago, I was contacted by an estate lawyer named Ira Mandlebaum. I was informed that, as the only benefactor named in the will of a Ms. Doris Melnick, I had inherited a lovely bungalow in Scarborough, Ontario. My excitement over this news was tempered by the fact I had no idea who Doris Melnick was. Nice last name, mine, but other than that, I drew a blank. Mr. Mandlebaum and I made arrangements to meet and sort this out.

I learned that Doris was a distant cousin who'd suddenly passed away in bed one night. She was discovered after several days, when the neighbours noticed newspapers piling up on the walk in front of her house. Also, her co-workers at FoodWorld had been concerned because Doris hadn't shown up at work and hadn't contacted her manager. VERY unlike Doris, so it was said.

There was no known family. The authorities contacted Mr. Mandlebaum because his phone number was the only phone number in Doris' address book. And the lawyer contacted me because I was the only family member named in Doris' will. After a LOT of ferreting around in my mind, I recalled hearing my parents talk, many years ago, about a distant cousin named Doris. It was a conversation they'd been having about sad, lonely people, if I recall correctly.

This all felt a bit overwhelming and, to be honest, I didn't have time for drama. I'm a very busy accountant, always on the move from work station to work station for a stationary company. And it was year's end, too. I was very much needed at the office.

But as the only known relative, I had inherited a house. I felt compelled to clean up that bungalow.

I started to remember some of the things my parents had said about this distant cousin, Doris. Nothing about her being eccentric. Just that she was plain and uninteresting, especially for a Melnick. And that she had never married and had lost contact with all of her extended family after the deaths of her elderly parents.

I met Mr. Mandlebaum at the Scarborough house. The lawyer hung back while I wandered through the rooms.

I expected to discover the house of a hoarder, full of newspapers and dirty tin cans piled up on counters. But the house was as spotless as my own one-bedroom apartment and, at first glance, there was nothing unusual about it. It was neat and entirely non-descript.

Except, as it turned out, there were boxes, cabinets, dressers, and closets full of drawings and writings by Doris herself. Paintings, too. You'd think that such a woman would draw kittens in baskets or write about morning rain and feeding pigeons. Wrong.

I must admit: Doris' startling drawings and her writing have no appeal to me. I think she was must have been very disturbed or, at least, under medicated.

(I'd like to mention here that the house has been emptied and cleaned and is quite lovely and on the market for a very reasonable price.)

How does one thank a dead distant cousin – never met – for gifting a house? I made it my job to see that this book got published, to make sure that Doris' years of notes and drawings would be seen by somebody, if not by a large audience. Frankly I don't happen to think that any of her art is truly worthy. But no matter, I get to see the name "Melnick" in a book. My father, the late Herb Melnick, spent his entire life selling cigars and lottery tickets out of his small variety store on the other side of town from Scarborough, in the Parkdale district, and although he would have hated Doris' drawings, Herb would have loved seeing his name on the page.

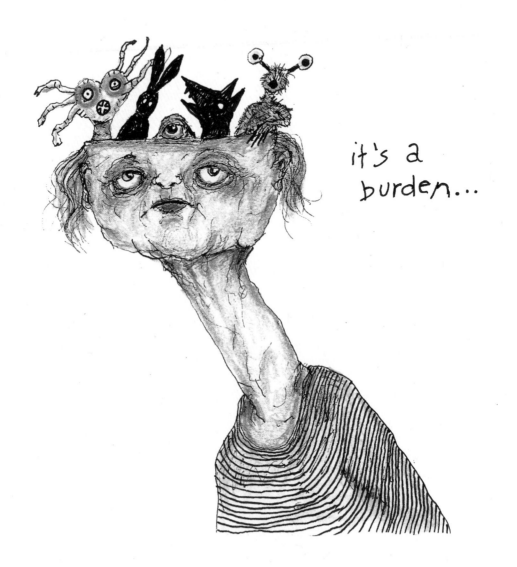

it's a
burden...

Serendipity by Lucille Melnick

I must admit that putting Doris' artwork and writings together in this book (any book) was a task beyond my capabilities. I know nothing about books, let alone why one drawing or painting should appear beside another. So, I have attempted a kind of chronology to the written words, and then have just kind of jumbled the drawings and paintings in between her writings. I've included the briefest of conversations with a few of her co-workers, and at the end a reflective piece by another co-worker who surprisingly wanted to have her say.

And I want to thank my friend M who lives out along Highway 89. He's a computer-kind-of-guy who loves assembling things. Designing things. He not only worked what I think is some magic with my mashup of material, but also got auteur David Cronenberg to introduce the book, and artist Terry Graff to say a few final words – so now we have this wonderful last testament to Doris.

It's all been a bit strange, and kind of a burden, which is why I was so pleased to discover a drawing that captured my state of mind entirely. Serendipity, as they say.

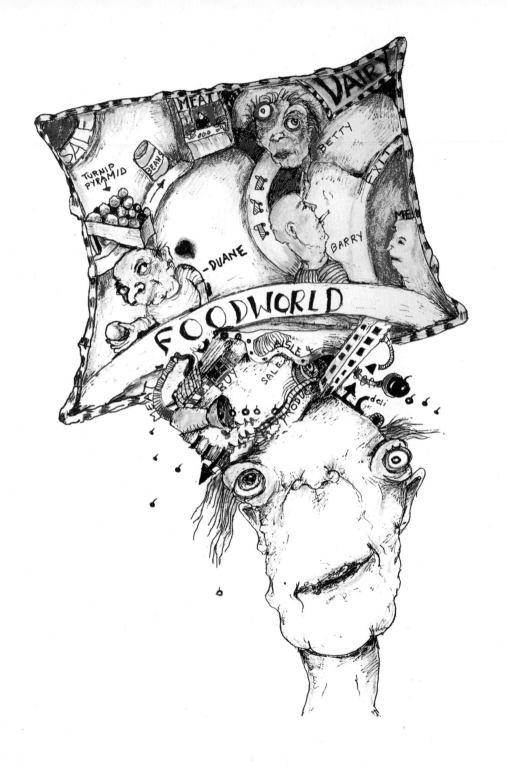

Co-Worker Interviews conducted by Lucille Melnick

I conducted these interviews as a way of introducing my distant cousin to myself. I hoped to find out what others thought she was like. I assumed that the people who had worked beside her for over 30 years would easily help me form some kind of image of Doris, would tell me who she was. Not so easy!

Leonard Cupsick butcher

"The only thing I remember about Doris was that she ate two hard-boiled eggs every day in the employees' lunch room. She brought the eggs wrapped in Glad Cling Wrap inside a brown paper bag. Every Saturday night, she bought her next week's supply of eggs. I guess she boiled them up on the weekend. She ate those eggs regular as rain."

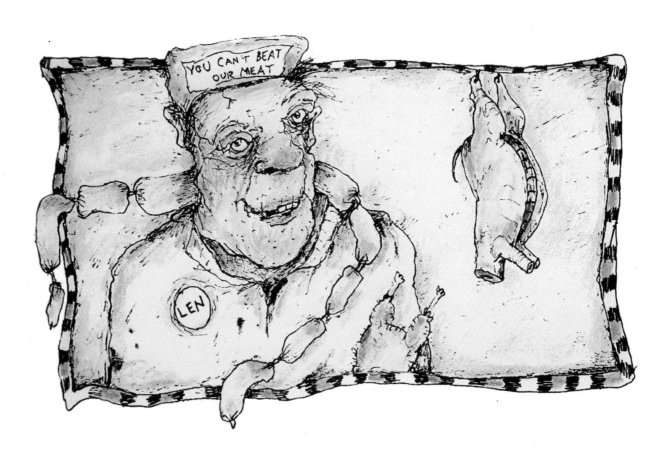

Betty Travers deli counter

"Doris Melnick was of average height, average weight, had brownish hair and a plain, flat face, what they used to call a pie face. Sometimes I thought the small black mole by the corner of her lower lip was a beauty mark she pasted on. I always had this weird feeling that she wanted to be a little bit beautiful. Don't we all? Does that help?"

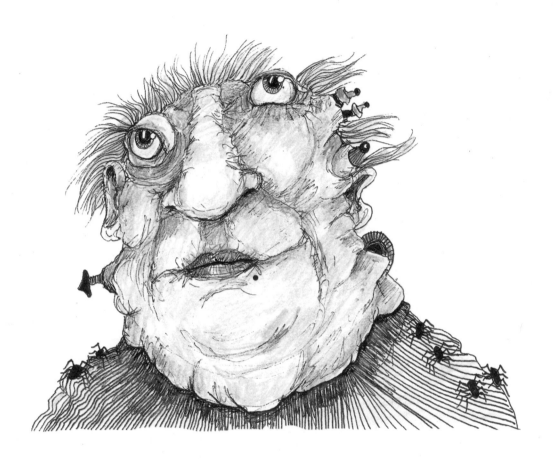

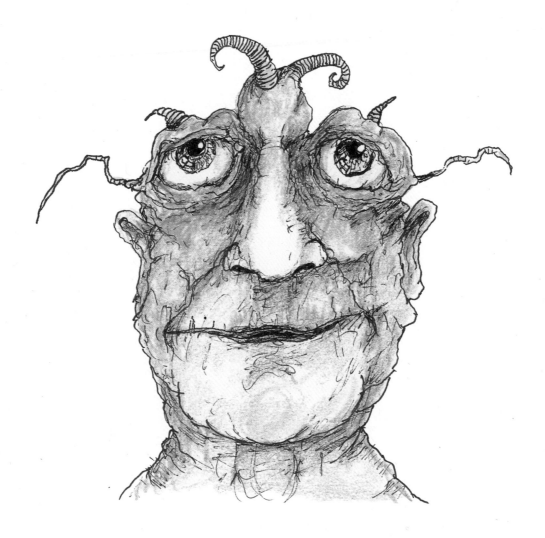

Barry McDonald assistant manager

"Doris sometimes sat with me outside while I smoked a cigarette. She herself didn't smoke. She was, in fact, very fastidious for a very fat lady. She never said nothing, just sat there, staring at her feet. So I smoked and stared at my feet. I think maybe her feet were bigger than my feet."

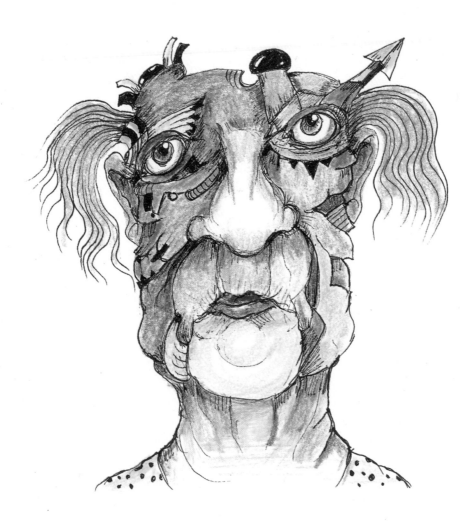

Leonard Entwhistle complaints department

"All I can say is that all day I listen to complaints, and I have my own complaints, which I keep to myself, but I got no complaints against Doris. She was okay by me."

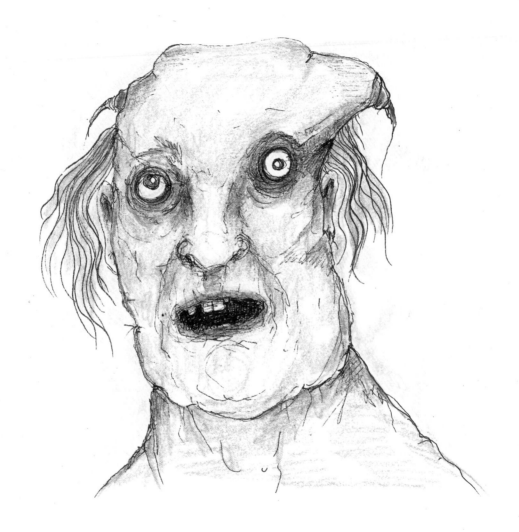

Joe Pesko outdoor gardening supplies (seasonal)

"You'll understand that I hardly ever had a word with her. There was no need, no occasion. We had our own cashier in the gardening unit. But there was one day, after I'd been working in the store for about five summers, that she came walking on by and for some reason, maybe because she was always alone walking through the lot to the bus stop – though I've got to say she never looked sad to be alone – I offered a gladiolus I was trimming, and she was completely startled as she took it, so startled I thought she was running away as she set out running for her bus."

Duane Long produce manager

"Doris used to stare at me all the time. Usually while I stacked turnips. It unnerved me. So much I once knocked my own turnip pile over. Tumbling everywhere. I said hello to her one time and she quickly hurried away. I swear she once followed me when I went to my dentist to have two teeth pulled. Why in the world would anyone do that?"

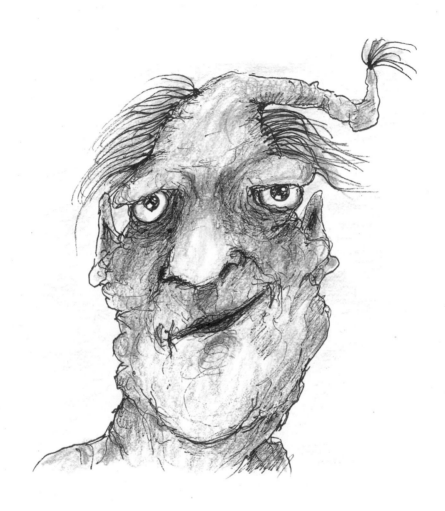

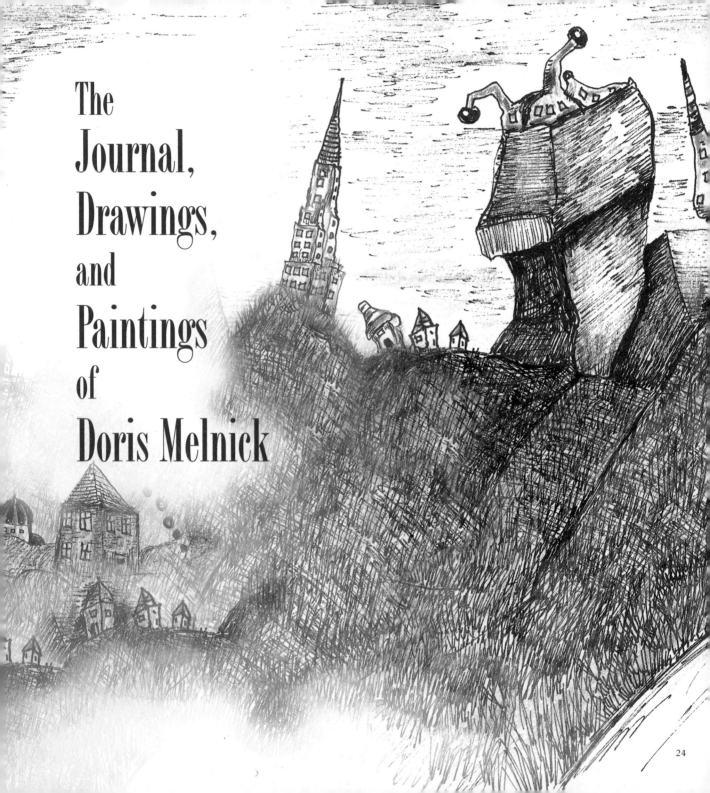

The Journal, Drawings, and Paintings of Doris Melnick

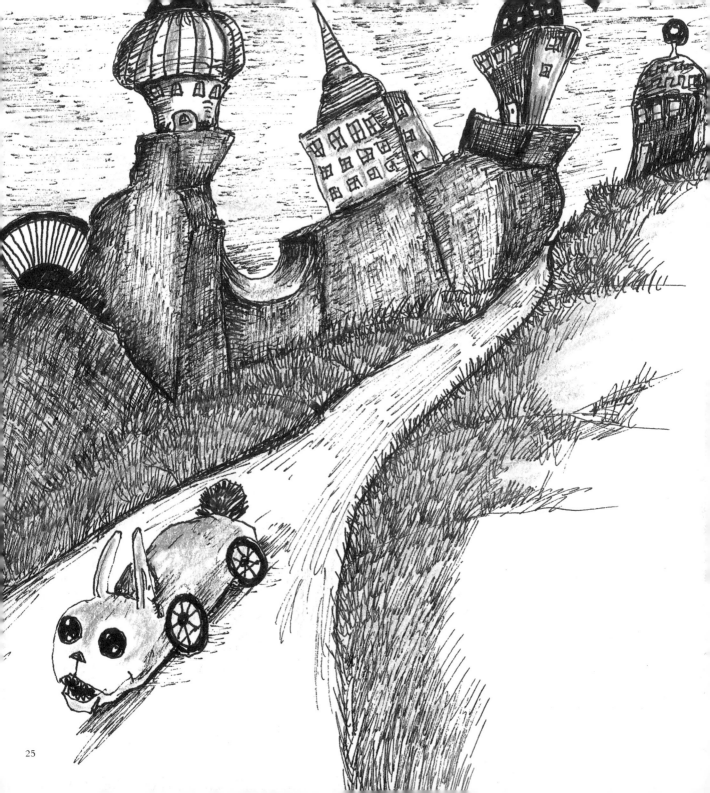

Duane Looked At Me Today

Duane looked at me today. I was watching him stack turnips, something I find mesmerizing. I could stare at him for hours, but I'm usually too busy on the cash, especially if they assign me to the express counter. I can run through six or eight items quickly, but there's always some old geezer who wants to buy 30 lottery tickets and that tends to tie me up. Last week a woman threw her cabbage at me because I was having trouble with the lottery terminal. Sometimes I hate my job.

I was staring at Duane, couldn't take my eyes off of him. I love his beard stubble, the failed comb-over. I love the way he touches the eggplants. But it's his turnip stacking that I truly find gripping. His sense of balance astonishes me.

I'll never tell Duane that I love him. Or that I've loved him ever since he took over the produce department from Ronald Shorter, who was a vile man. Ron spat on the vegetables. I saw him do it more than once when he was polishing the tomatoes.

I was staring at Duane and suddenly he looked up and saw me and I totally lost it. I turned and RAN. I knocked over the sweet potatoes, I was so embarrassed. I need to avoid Duane for a while.

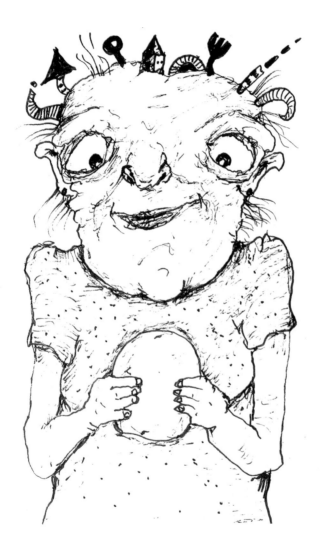

he touched
my
turnip

Sometimes I worry that he saw me following him last month.

But I have NO REGRETS.

It started last month when I overheard him telling Harold, his assistant, that he had to have two teeth pulled at the dentist later that day. I wasn't listening in, really. Duane has a loud voice.

When I saw him leave the store, I booked off and followed him. It reminded me of a game I played as a little girl, a game called, "Diabolical Cunning." The little girl next door and I would follow strangers on the street and if the stranger noticed you following, you had to drop out of the game. Whoever was left was the winner, and I won every time. These strangers never saw me. The girl next door was what my mother called "obvious." I was not. So I knew that Duane wouldn't see me. I'd practiced my entire childhood.

His dentist's office wasn't too far and I waited outside for an hour after he went in to have his teeth pulled. I'm good at killing time. I like to watch random people and guess which one of them likes soft-boiled eggs and which hard.

After Duane came out of the dentist's, distracted and in obvious discomfort, I went into the office and asked to speak to the dental assistant. I won't go into details here, but let me just say that, for a hefty sum, I managed to bribe the dental assistant and she gave me Duane's molars. She even washed them for me. She didn't ask any questions, just took my money and hurried away.

Later in the week, I bought some clay and paint from the art store and I spent the entire night (some things are more important than sleep) creating my DuaneHead. It's not a very good likeness, but with Duane's molars mounted on top of the head, it reeks of his aura. I now have a part of Duane in my house.

I placed DuaneHead on top of the fireplace mantel. I talk to it all the time. I say things I wish I could say to Duane. Sometimes I can hear it talking back to me. I haven't felt lonely since DuaneHead has been installed in my house.

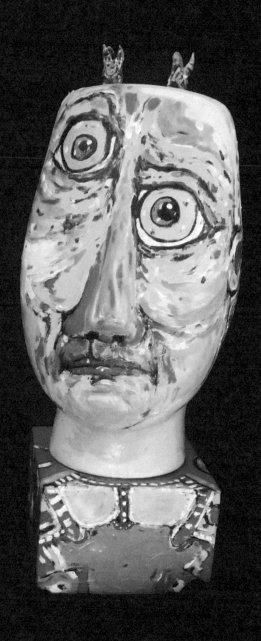

Eugene Benson, dairy and poultry counter

Eugene sold me my eggs every Saturday night. He was a prankster, he was nasty. An egg is a beautiful thing, its shape. So white. Even brown eggs are beautiful. Maybe in my life I'm the brown egg. But eggs are eggs, except Eugene, as he counted out 12 eggs for my egg carton, he'd suddenly close his fist and crush an egg, letting all the wet innards leak through his fingers, letting strings of gooey wetness dangle in front of my face, and he smiles this awful smile, like he was having a really good time that he'd waited to have all day at the expense of my shock and revulsion at someone like him. And then he'd wipe his hand clean with a towel like nothing had happened and count out the rest of my eggs.

I have drawn Eugene. I think he looks like a diseased turnip. He certainly wouldn't fit into Duane's pyramid pile.

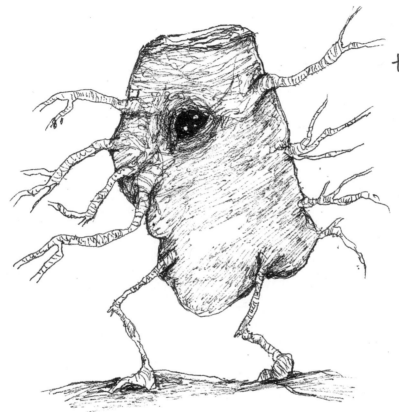

the root of
all evil.
His name is
Eugene.

My Sausage Poem

This grocery store, a microcosm,
The people so mundane
I take a break, remove my hat
And visit the deli again.

The roast beef doesn't interest me
Nor does sliced ham unfurled
However, rows of sausages
For me become the world.

The Bratwurst speaks in German
"Hor auf mich anzuschaun" it whines (stop looking at me)
I quickly look away
Aware of hostile signs.

Hungarian summer sausage
So fragile, some might say
It looks at me and says "Segits!" (help me)
But I just look away.

Chorizo mumbles "OLA"
A dozen times, but then
I remember younger days
And all those Spanish men.

I hate the damn kielbasa
It looks at me and screams
"Jesteś brzydka," because it thinks (you're ugly)
I don't know what it means.

Mortadella likes to whine,
In short annoying bursts
"Sono annoiato," then slowly turns (I'm bored)
Toward the liverwurst.

Tower of Babel at the deli
United Nations behind glass
The sausages all talk to me
And help the boredom pass.

I head to my cash register
Bag celery and onions
I think about exotic climes
And focus on my bunions.

On the Bus

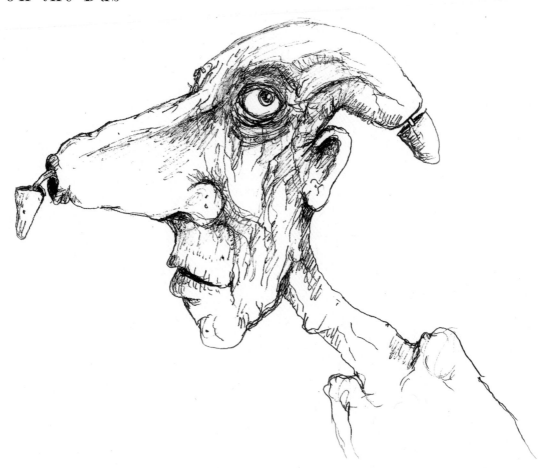

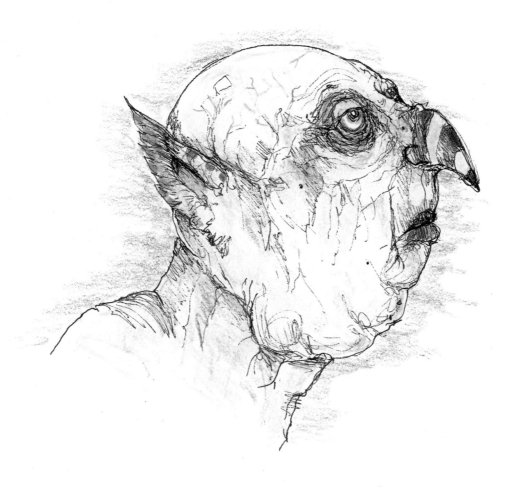

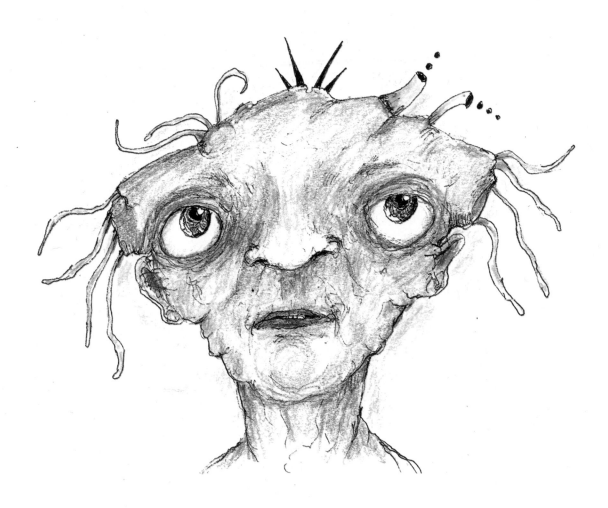

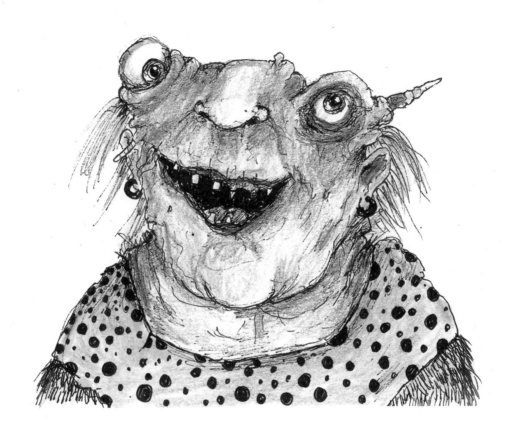

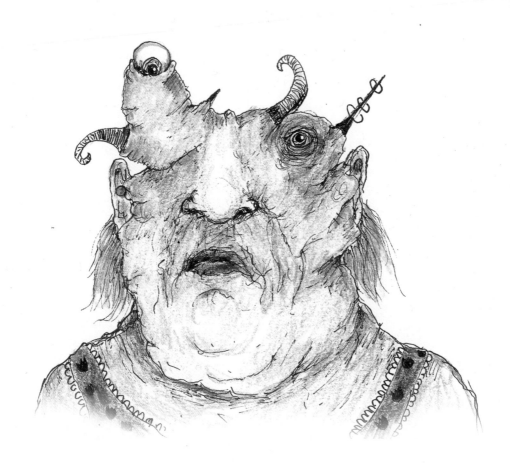

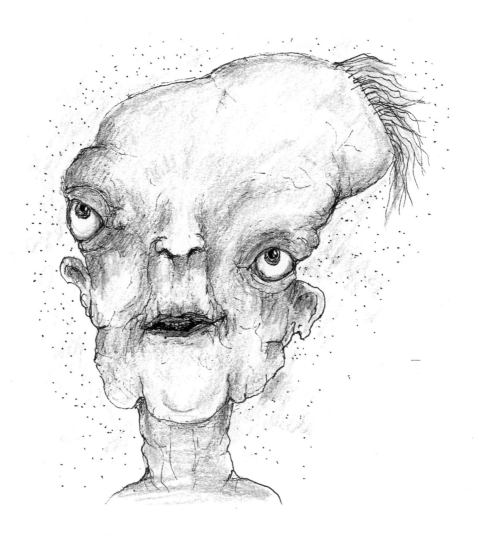

Entry for April 16

I didn't sleep last night. I sat in my favourite chair (a brown corduroy beauty I got at Goodwill three years ago, a $20 bargain) and I've begun to think about my next set of drawings. I have drawn people that I see riding the bus, and some of my co-workers – I liked doing that – but my favourite way of drawing is just…beginning. No plans, no ideas. Maybe the things I draw are stored inside my pen. I think about that a lot. Maybe I'm just the conduit for some sort of magic that was put there by a witch who works in the pen factory.

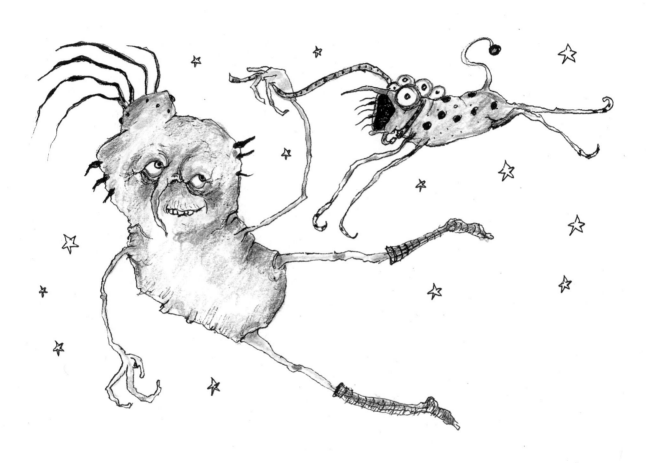

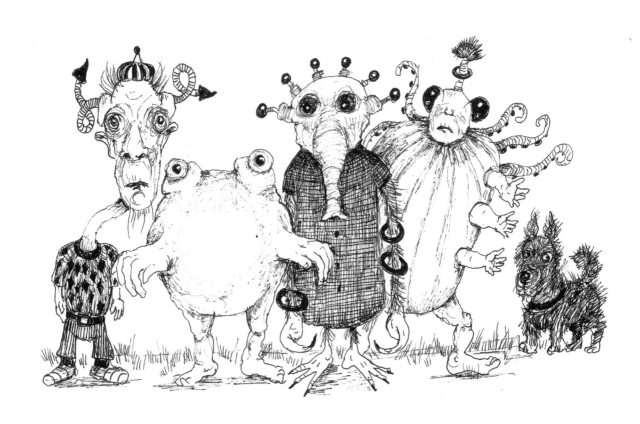

I wonder if anybody will ever see my artwork? Or read my poems and little stories?

I wonder if Duane would think more of me if he saw what comes from the inside of my head? People mostly assume that I'm dull and boring and I guess I am. I've worn my hair in the same knob for 30 years. I wear black every day. Black sweaters, black slacks, black shoes. Black hides fat and food stains.

I eat my boiled eggs for lunch every single day. And a tin of baked beans with molasses and lard for dinner, along with a bagel bun to mop up the sauce. I should eat more fruit and vegetables, but that would mean shopping in Duane's produce department and the thought of that makes me anxious. I sweat when I'm anxious. Duane was off work with the flu for a few days last year, so I bought a head of lettuce and some bananas and some cobs of corn. I prefer canned corn, niblets. But overall, I prefer baked beans.

I was talking about my drawings and paintings. I have hundreds of them. I should try to organize them in some way, but it makes no difference, really. Who's to care about them but me. My life has been so dull. I've never travelled anywhere, never kissed a man, never owned a dog. But I haven't felt cheated, and I've never longed for adventures.

I've created my own world, my own friends. And I share them with NOBODY. Even writing this down makes me feel special and powerful. And at the same time, very wary. I don't know how I'd explain all this to the other girls working the cash registers. I think about this a lot, especially when a customer's rude to me at work. Last week some miserable old crone yelled at me for giving her the wrong change. That night I pictured her being eaten alive by rabid wolverines. Easy to explain. Yet hard to explain, if I had to.

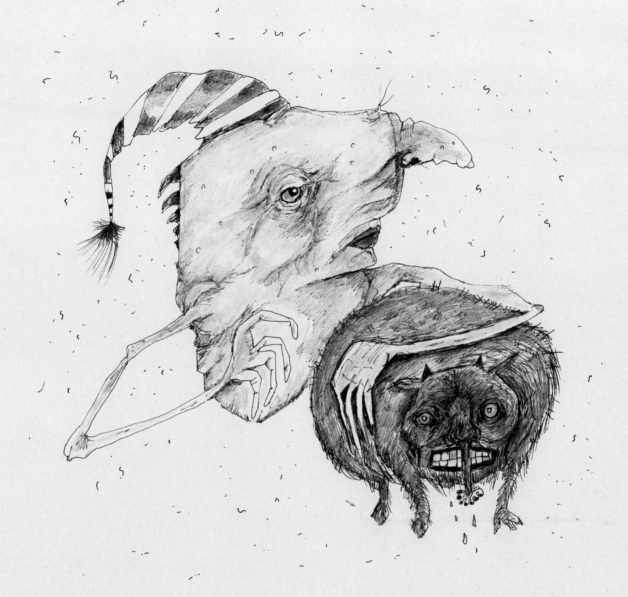

Sometimes, I inexplicably miss my parents terribly, although, to be honest, we were never ever close. Mother could be violent. She was violent. That's how she paid attention to me. Wielding her wooden ladle at my head. My father, who sometimes treated me like a fellow prankster – especially whenever we went to the racetrack – also liked to call me fat and lazy.

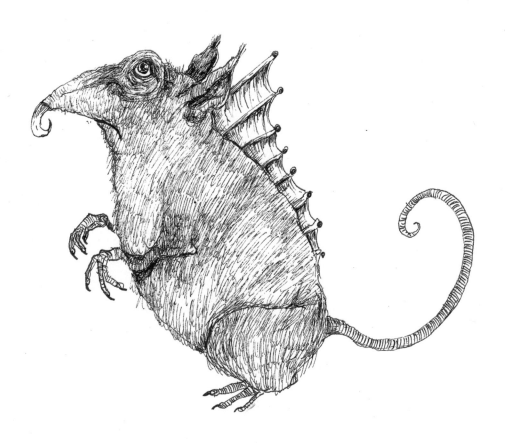

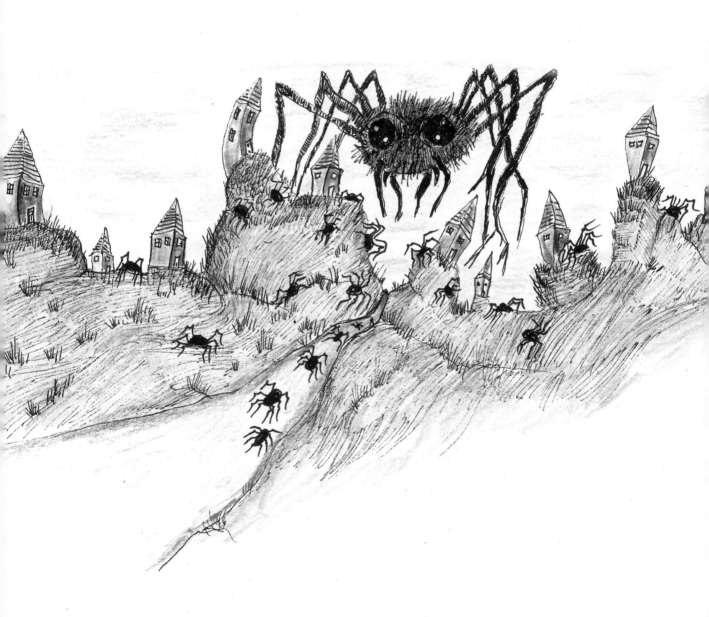

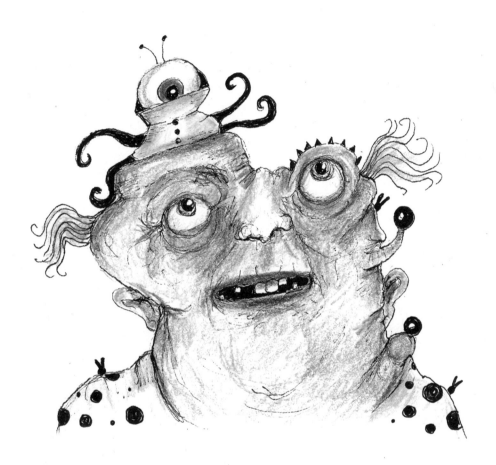

Meanwhile, customers at FoodWorld don't even look at me. They seldom make eye contact. It's gotten a lot worse since everybody started carrying those stupid cell phones. I used to make idle chatter with people, but now I listen to their phone conversations. Last week I listened while some young woman, covered with tattoos, talked into her phone about the abortion she'd recently had. I found this terribly exciting. Years ago, I had to listen to customers chattering on about the weather but now I get to hear all the details of things like medical procedures. Invasive interventions. Phrases you usually don't get during a three-day forecast from a woman holding an eggplant. Anyway, the difference these days is, nobody is talking to ME. There's something awful sad about that.

I'm not sure about this journal. It feels strange, writing all of these things. But it feels good getting some of my head thoughts on paper. My brain doesn't feel so crowded. Then again, that's how I feel when I draw, too. Less crowded.

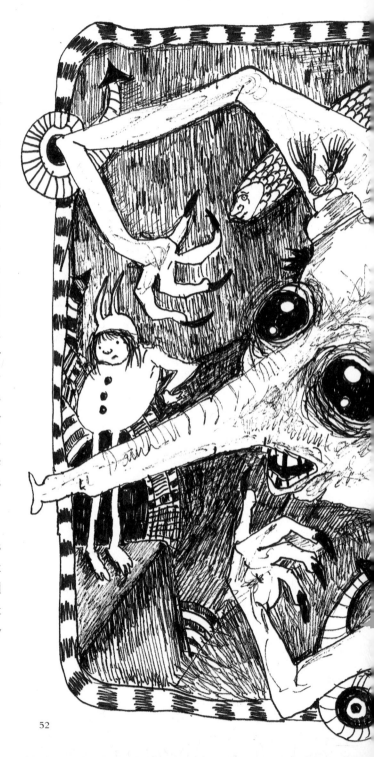

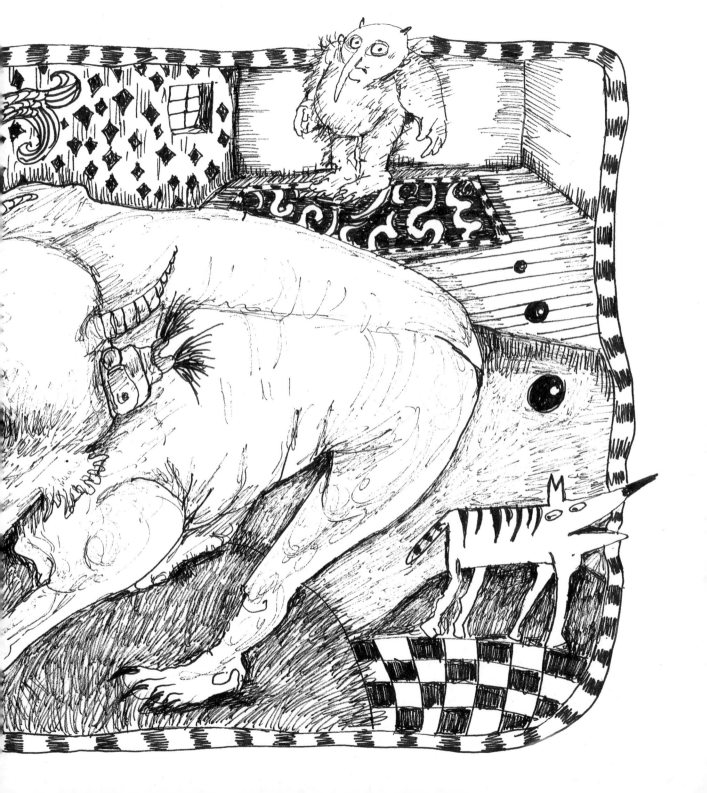

The Racetrack

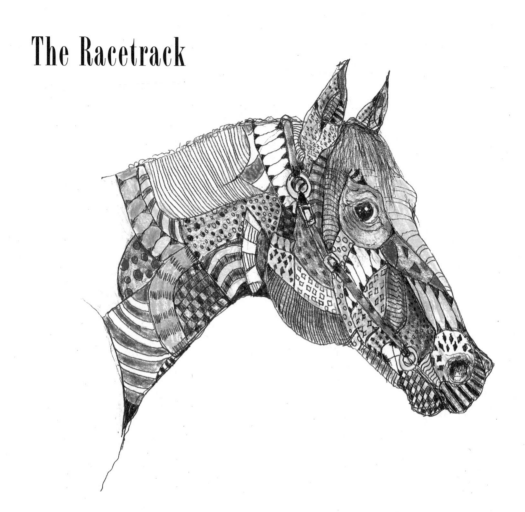

When I was about eight years old, my father took me to the racetrack one Saturday in autumn. Ostensibly, it was to let me spend some time around my favourite animal, but the truth is my father loved to gamble.

Everything about the racetrack filled my heart with joy. The smell of the leather bridles and the liniment, the soft breeze blowing through the willow trees by the paddock. The tiny jockeys, no bigger than me, nervously tapping their whips against their thighs before being hoisted onto the saddle.

And oh… the horses. I climbed onto the paddock railing, too excited to utter a word, gawking at these beautiful creatures. Bays, chestnuts, greys, all muscled up and bursting with suppressed energy. Frothing at their mouth, and rearing while the grooms struggled to control them.

My father, happy to see my enthusiasm and probably thinking that he may have a future cohort to accompany him to the track on a regular basis, let me choose a horse in the first race. I took this task very seriously and when one of the animals looked directly at me, I made my choice. "NUMBER THREE!" I yelled, loud enough for every track rat in the vicinity to hear me. I remember his name, it was Kingwood. I've never forgotten it. And my dad placed his bet.

My father and I watched the race down by the railing, right at the finish line. I had to watch the race by looking through the rails. Most of my excitement came from watching my dad's face turn red while he screamed and smacked his program against his leg.

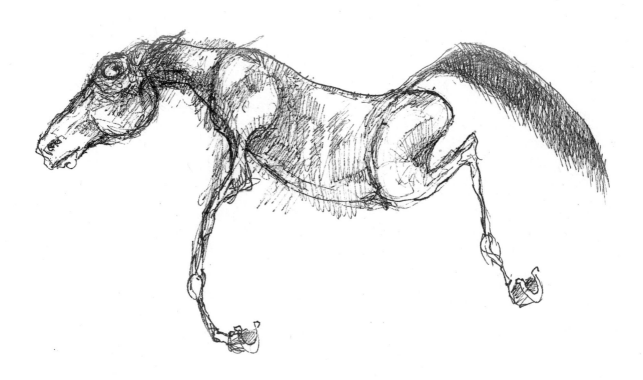

Kingwood was leading down the stretch. Kingwood won.

My dad was ecstatic and told me I had a "gift."

Then he told me to sit down on a bench and wait for him while he cashed his ticket.

It was the best day of my life, I thought.

It felt as if my heart was going to burst out of my chest.

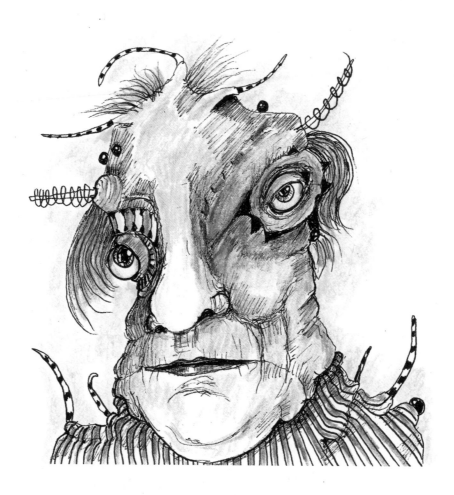

While my dad was in the clubhouse, cashing his ticket, my eyes wandered around the crowd. I noticed a man standing by a bench, not too far from me. He was wearing a heavy coat, which was odd for a hot fall day. And suddenly his coat fell open and I saw a strange, purple object hanging from between his legs. The man had a big grin on his face as he saw me gawk at it.

Now here's the thing: I'd never seen a penis before. I hadn't a clue what that purple thing was. I concluded that it was some kind of deformity. My parents taught me to always be thoughtful and kind, especially towards people who are "different." I looked at the man's face with as much pity and compassion as I could muster. I wanted him to know that although he possessed a horrible, ugly deformity, I would not mock him or judge him.

When he saw my look of pity, he quickly pulled his coat around him and walked away. I felt so proud of myself for being understanding and kind.

When my father returned with his winnings, I didn't bother telling him what had happened, even though I knew he would be proud of me. Besides, I was quickly distracted by his promise to take me for ice cream on the way home.

I had spent a wonderful day with my dad, I'd been close to the most beautiful animals I'd ever seen, and I had picked a winner.

I was the luckiest girl in the world.

I'm Not Sure Why

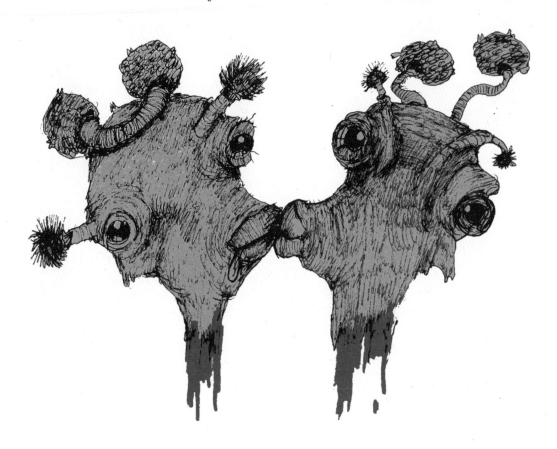

Written in pencil on the back of this drawing: "the lovers."

I'm not sure why I'm writing these little notes down, why I want to get these thoughts out of my head. Except, I know that whenever I have written something down or done a drawing, I get to feel unstuck. Lately I've been stuck a lot. I'm not too familiar with the mechanics of sex, so I don't think I could draw how I feel about it (although, when I was still a girl, a couple of years after the racetrack, I drew my idea of a naked man and a naked woman, and I got smacked by my mother. Maybe that's when I got "stuck.")

There was never a hint of sex in my house. My parents slept in separate bedrooms. I never saw them kiss; never saw them hug. The only physical contact I witnessed was my mother grabbing my father's arm when he was reaching for his tenth beer. Some kids at school would joke about the noises they heard coming from their parent's bedroom and I used to wonder what they were talking about. I never heard my mother moan except once, when she had food poisoning from eating tainted cabbage rolls.

When I got older and saw sex scenes in movies, it took me awhile to understand that there was something going on that the man and woman were enjoying. I swear, the first time I saw a couple having intimate relations on a movie screen, I thought somebody was getting hurt. And all that "OH GOD" stuff. What did God have to do with it? What does religion have to do with any of this? I was so confused.

I finally put it all together, of course, but it never had any allure for me. I've never desired any intimate contact, to be honest. I never wanted anything in me for God's sake.

Until NOW.

It's Time for Me to Think

It's time for me to think about getting ready for work. Eight hours on the cash register, with a half-hour break for my hard-boiled egg lunch. If I'm lucky, I get to stare at Duane when he's polishing and stacking and piling. The light gleaming off the top tomato. Unfortunately, turnips don't shine. I like having all the food lined up and stacked in the aisles. I like the fresh fruit and vegetables in their rows and piles, particularly if they're in pyramids. I read somewhere that pyramids create a special energy.

I like to think of Duane as being in charge of energy, a kind of pharaoh of turnips. One of the funniest lines I ever read was, You can lead a horticulture but you can't make her think. I wish I could tell that to Duane so I could hear him laugh, being – as he is – in charge of all the horticulture in FoodWorld.

I like order in my daily life. At least all those voices are, in the store, in order. Who knows what they were saying in the ground, underground (imagine if all the horticulture, all the plants, each and every one of them, was thinking. What a cacophony of thought, and if it was somehow out loud). Order is in the balance that comes out in my drawings, I suppose.

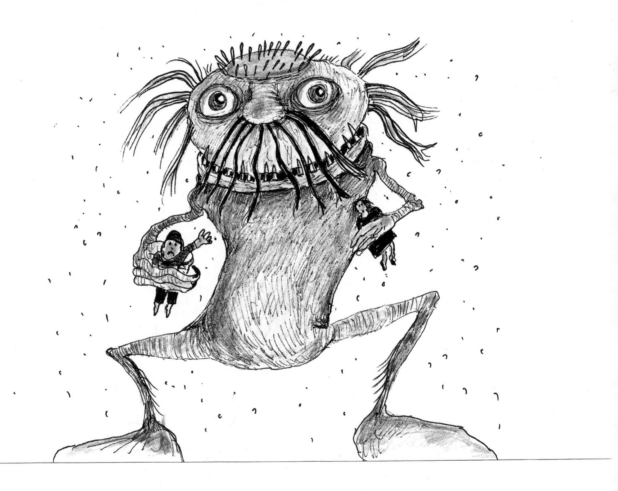

I spent a lot of money on the blank book for this journal. I'll feel disgusted with myself if I abandon it, a feeling of disgust that is way too familiar to me.

Disgust has a taste. Sour. Like you get from heartburn.

It's all the heart's fault.

Mostly, when I feel a burn coming on, I stare hard at the blank pages.

They don't frighten me. Sometimes I feel, if I've stared long enough, that I've fallen into the blankness. Suspended in there, wherever there is, and then I write a word, or draw a drawing, and I'm back to normal.

Like I say, I like neat and normal. It's my darn toaster that gives me trouble, it seems to somehow leave toast crumbs all over the counter, each little crumb, if I had it in the palm of my hand, gradually becomes one of my monsters, one of my characters. For the life of me, I don't know why so many of my characters end up devouring each other.

People should be more suspicious of the crumbs who surround them.

I'm Not a Fearful Person

I'm not a fearful person. I spent most of my childhood flipping over flat rocks so I could study the creatures that lived under them. Sometimes I run across the street when the traffic light is amber. I ride public transit.

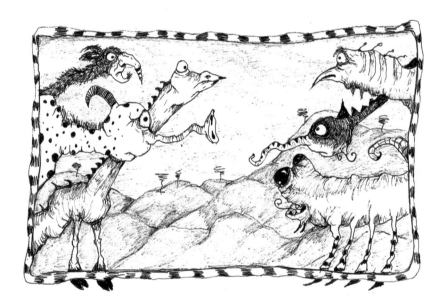

But I'm terrified of the creatures that live in my basement. And I blame mama's ladle for that. I blame mama's ladle for a lot of things, but it's the monsters in the basement that give me the most grief, fill me with terror, and cause sleepless nights.

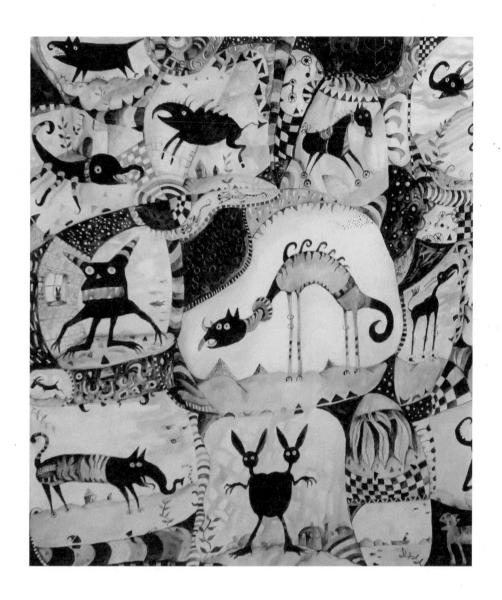

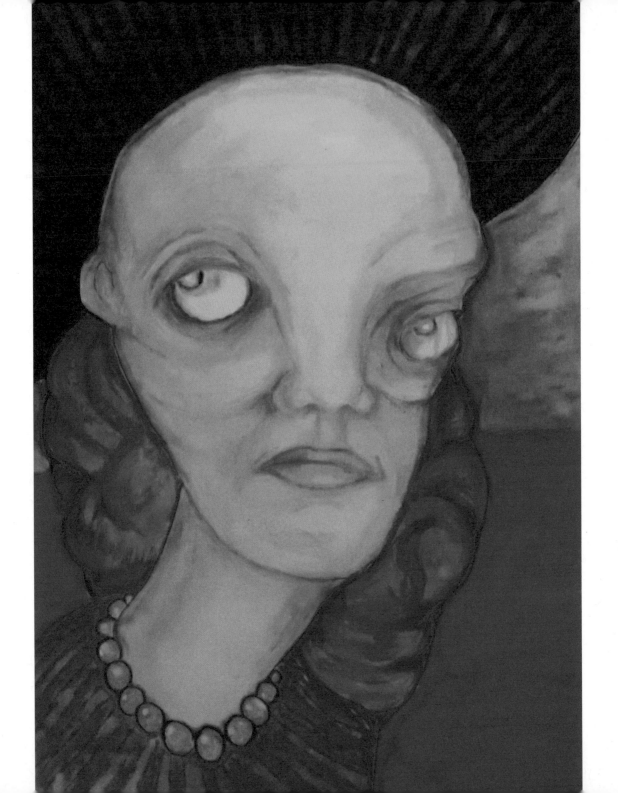

Mama wasn't a nice person. She managed to hold herself together when out in public, but when we were home, she would remind me, all the time, that I was a huge disappointment, a hideous excuse for a child, and the main reason papa was seldom home in the evenings. She told me that her life took a downwards turn after I was born, that every awful thing that happened to her was my fault, including her fat ankles, her rotten teeth, and the fact she was friendless.

To drive home these things, she would come at me, fire in her eyes, with her ladle clutched in her fist. That ladle had no practical purpose other than to keep me in line. I never saw it go into a pot of soup or stew.

That ladle often made body contact. I had round welts on my forehead, my arms and my bony little bum.

My escape was the basement. It was big and dark and there were lots of corners where I could hide from a ladle with an angry mama at the end of it. She never came after me if I fled to the basement. It was my safe place. I'd stay there until I could hear her put the ladle back into the drawer with a loud slam. That was my signal that it was okay to go back upstairs.

As I got older and faster, I was able to avoid the wrath of the ladle most of the time. I would flee to the basement the moment I saw mama reach for the drawer handle.

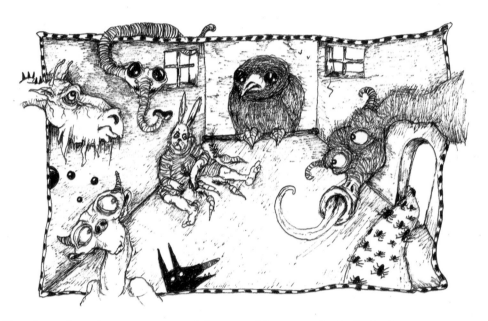

One day, when she was angry and frustrated because the ladle hadn't connected with my skull, she told me that she didn't chase me down the basement stairs because she hoped the terrible basement dwellers would catch me and if they DID, they would wreak much worse punishment on me than a mere ladle.

I looked at mama with disbelief, although I was aware that there were some strange smells and sounds in our basement. She saw my expression and began to describe the monsters that lived downstairs. She said she knew they were there because they came with the house. They'd eaten the previous owners and refused to vacate.

She described these creatures in great detail. They had long fangs and tentacles and grotesque eyes and protruding lumps and boils. She assured me that they loved the taste of children's flesh.

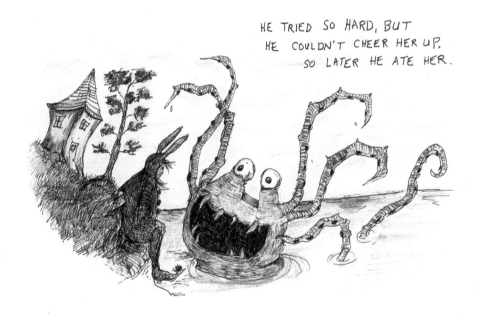

HE TRIED SO HARD, BUT HE COULDN'T CHEER HER UP. SO LATER HE ATE HER.

That was the end of the basement as my safe place. I was covered in ladle welts after that but it seemed like a reasonable trade-off.

I still live in the same house and mama is long gone.

I threw her ladle into the dumpster behind FoodWorld many years ago.

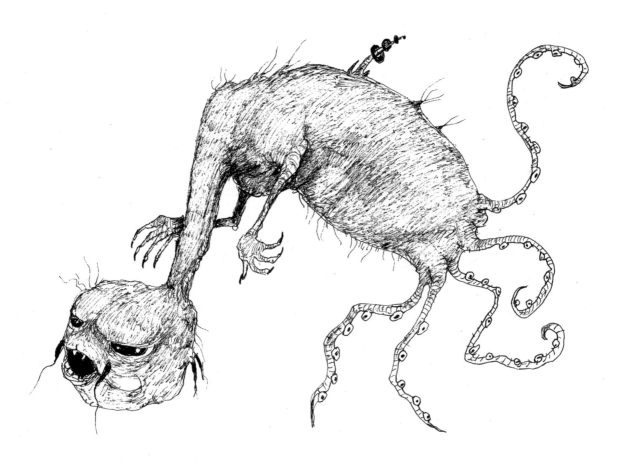

But I never, EVER, go down to the basement. I hear strange noises and sometimes there's a weird, fetid smell that wafts up through the forced air furnace vents but I try to ignore it or else I put Vicks VapoRub under my nose.

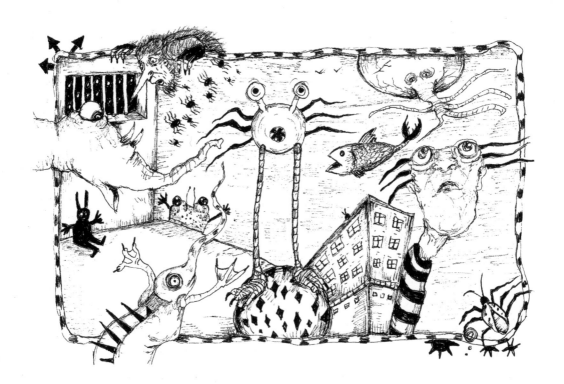

I'm not sure if I believe in ghosts, but if they exist, mama is down there, along with those other creatures, waiting to come at me with that damn ladle. I don't want to face the monsters and I KNOW that I don't want to see a ghostly vision of mama with the ladle of doom in her fist. My hope is that her monsters get her.

I keep the door to the basement closed at all times. I have a huge, heavy wooden chair in front of it and bricks on the seat of that chair.

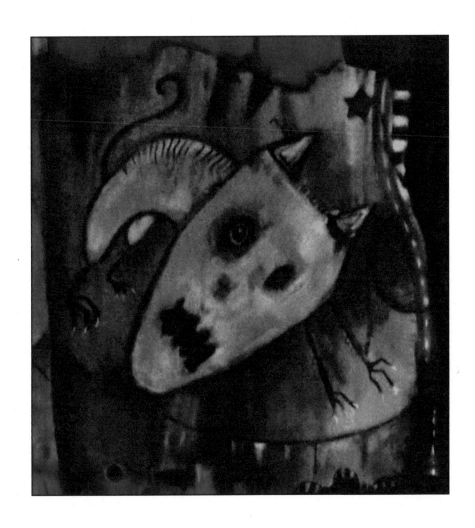

Duane Long Was Hired

I've worked at FoodWorld for over 30 years. About 10 years ago, a man named Duane Long was hired as produce manager. Duane's about my age. He's tall, balding and wears glasses. (I like him best when he takes off his glasses.) I really didn't notice him very much at first, he kept to himself and was constantly stacking turnips or arranging expensive Honeycrisp apples in nice little pyramids. Pyramids are hard to do. Duane takes his work very seriously. I once witnessed a customer return a package of strawberries that had rotten berries at the bottom of the container. Duane turned bright red with embarrassment, sputtered clumsily, and ran to the back to get the woman two free boxes of strawberries. He was so upset, he had spittle all over his chin. It was adorable and from that moment on, I haven't been able to stop thinking about him.

And now I lie in bed at night and wonder what Duane looks like naked. Does he have hair on his chest? What do his thighs look like? What does IT look like? I can't believe it could be purple. I can imagine all kinds of deformities, but not that.

I think about kissing him. I see his face in my embroidered throw pillow (made by my mother, which doesn't enhance the mood) and then I put my lips against the pillow, imagining I am kissing Duane's mouth. I can almost feel his beard stubble. I can almost smell the onions that he always eats at lunch.

And I start to get feelings I'd never had in my entire lifetime and I know they have something to do with the couples rolling around on the movie screen and the noises coming from the bedrooms of my friends' parents. I am getting close to SOMETHING, but I have no idea what it is.

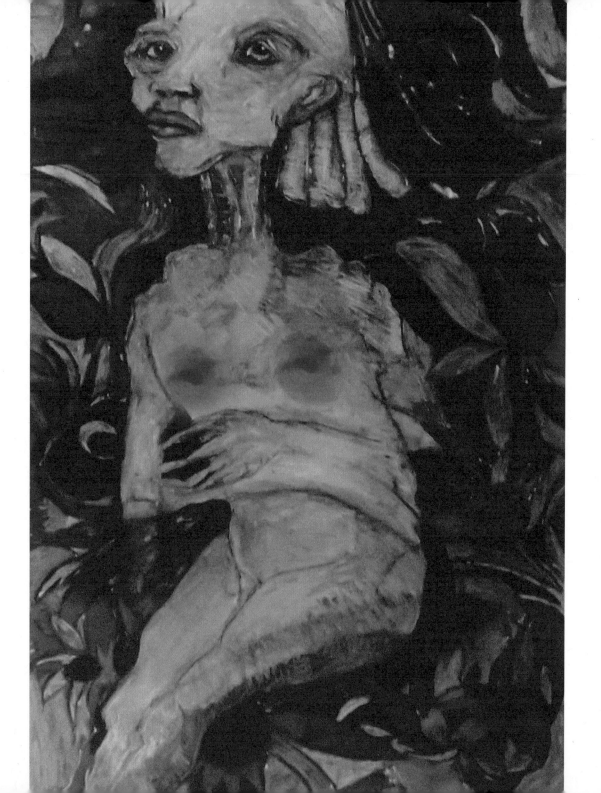

I've never known how to approach Duane in a way that isn't work related. I once brought his attention to a banana that was rotting on the shelf and I complimented him on his fresh zucchinis, but I don't know how to take it further, to make it more personal. And Duane hasn't been very helpful in this regard. He seemed to appreciate me commenting on his zucchinis but quickly turned away and resumed helping out on that day by lining up the Spanish onions in neat rows. He's almost anal about his produce. I think that's the right word. Is that an indicator of what kind of lover he'd be? I haven't a clue.

I will NOT give up. I am determined to get closer to Duane in some way. I need to be held by a man just once in my lifetime. I want to feel what it's like to be kissed, to be touched. I'm longing for it, to be honest.

I'm feeling strange and uncomfortable now. I'm going to go draw for a while.

Written in pencil on the back of this painting:
"Imagining myself as a thin woman waiting for Duane"

For D. (the produce manager)

Look at me, I say quietly.

You do not hear me.

Your hand rests on a turnip.

Your eyes radiate love when you hold a red cabbage.

Look at me.

How do you know my skin is *not* smooth as an eggplant?

Perhaps my neck is soft as a peach.

I see you smell the mandarin oranges. They are sun, they are warmth.

I smell of eggs.

Look at me. The eyes of the potato are blind. I SEE YOU.

I see everything you are. Everything we could be in a real fairy-tale world.

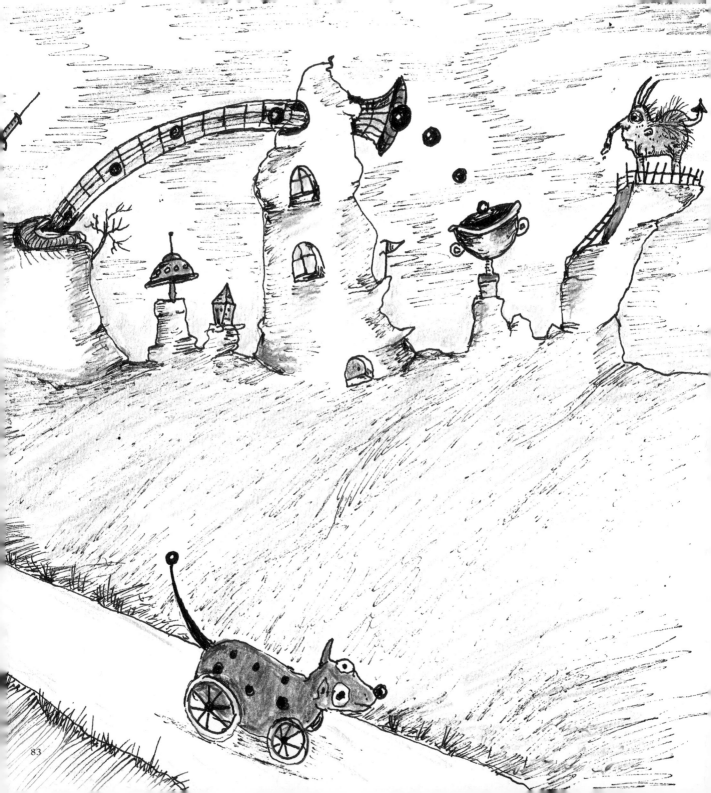

All About "Reputation"

A couple of years ago, my store manager insisted that I get my eyes checked. Apparently, I'd been charging people twice for a lot of their checkout items. Several complaints had been made. And Lawrence, the store manager, was running out of excuses and free coupons. One would think he'd be grateful that I boosted his profits, but Lawrence is all about "reputation." You'd think if that's what he cared about, he'd stop trying to grope Sherry the bookkeeper, but that's another story.

So, I took myself to Morrow's Optometrist/Optician, in the west end of the city. No special reason I went to Morrow's, other than I'm fascinated by the giant eyeglasses that hang over the entrance. They light up at night and flash off an on. And they're bright green. Fabulous.

During the eye examination, Dr. Morrow had me look through a huge whirligig and wheels contraption and asked me to read the chart on the wall. "Which one?" I asked. According to my eyes, I was looking at two charts. This caused Dr. Morrow to bristle with excitement. He probably conducted this test dozens of times daily but didn't often get a subject that saw two charts when there was only one.

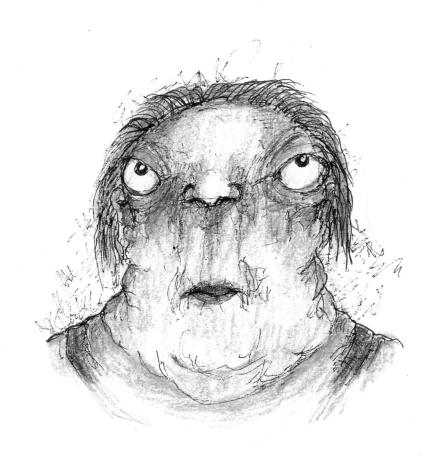

Turned out I had double vision. This usually means something ominous – multiple sclerosis, brain tumor, myasthenia gravis. Dr. Morrow immediately sent me to my general practitioner who – after fat-shaming me the way he always does at the start of every office visit, making me take off my brassiere – referred me to a neurologist.

The neurologist asked me how I maneuvered through the world with double vision. I responded that I simply looked straight ahead and divided by two. I thought this was hysterical. Funny hysterical. The neurologist glared at me. To provoke him, I said that sometimes 2 and 2 equaled 5 – I saw lots of things I wasn't responsible for, and that's life. He told me I was too smart for my own good. I know he meant smart-assed.

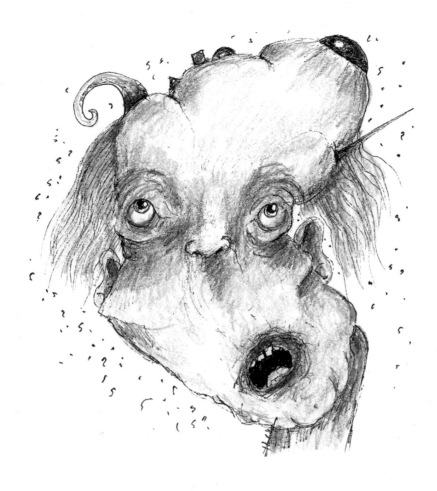

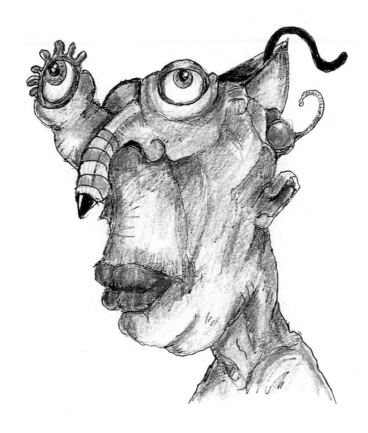

To make a long story short, after many tests (some were simple, others complex and painful), it turned out that I didn't suffer from any terrible affliction. I merely had weak eye muscles that weren't doing their job. I wish they'd known this before they sent me to the myasthenia gravis specialist, a sadistic woman who put electrical probes into my head and repeatedly zapped me. I expected her to scream "IT'S ALIVE!" when I stood up body and senses intact at the test's conclusion. (She did not.)

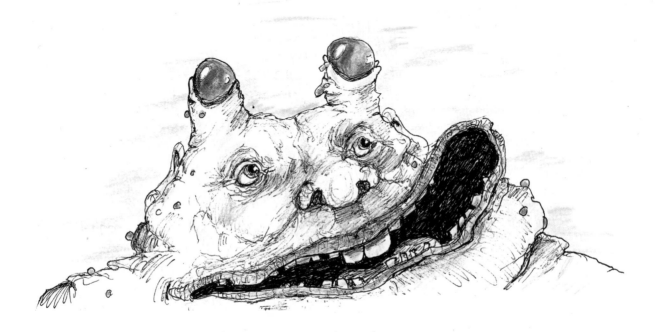

I was sent back to Dr. Morrow, who prescribed prism glasses. I love my prism glasses, they are incredibly thick and strange looking. I wear them at work, so I won't make any more mistakes, but I never wear them at home. Now that I'm paying attention to my double vision, it really is a lot of fun. It feels as if I own two of everything, including two televisions. Mind you, I long ago got bored by television. Ended up keeping it on the test pattern channel, and then they stopped that, so I just leave it on a weather station with the sound turned too low to hear anything.

Back to my eyes. There was something else that changed for me after my double vision diagnosis. From the beginning, all my creatures, all the people, have had strange eyes. Eyes appearing on stalks. Eyes bulging out of heads at various angles and looking in different directions. I seldom draw eyes of equal proportions. Who's going to stop me, the eyeball police?

After experiencing a lifetime of blundering through walls that didn't seem to end, blurry landscapes that went nowhere, and after never being sure where boundaries were, "out of focus" is now my norm.

Their eyes are my eyes.

I Hate Cats

*Y*esterday I was sitting outside FoodWorld. Barry McDonald was standing beside me, smoking. This happens once or twice a week. We seldom say a word to each other, but I like Barry's energy and want to get closer to it. Also, I like the smell of cigarette smoke. Mom was a smoker, too. Oddly, that smell for some reason comforts me.

Barry suddenly asked me out of nowhere if I had a cat and seemed surprised when I said "no." (That was the extent of our conversation come to think of it, he was, after all a little strange.) Anyway, older, unmarried women are expected to have cats.

I didn't go into details with Barry. Barry always has something between his teeth. Poppy seeds or celery bits. Mostly I stare at my feet. Because I can't look at him without staring at his teeth and I try my best to not be rude

On the bus ride home, I began to think about cats.

I hate cats.

If I DID live with an animal, it would be a dog. I'd love to have a big, black dog. I'd name it Satchmo if it was a boy and Ella if it was a girl. I grew up in a home where jazz was always playing on the radio and I ate my morning oatmeal listening to Louis

Armstrong's trumpet. And when I couldn't sleep, I'd sing "What a Wonderful World" to myself.

Cats are evil. Even when they live in a nice house and are fed every day, they hunt and kill birds. They don't even eat them, they just commit murder. My neighbour had a cat that used to bring dead bunnies to the front door all the time. BUNNIES. What horrible creature kills bunnies?

Betty came into work one day with bandages all over her right arm. She said that her Siamese cat, Otis, had attacked her. She's had Otis for nine years, she loves that animal. And he viciously attacked her. She laughed when she told me about it and said it was her own fault for dangling her arm off the side of the bed. I would've strangled the beast.

Cats lie around all day, thinking evil thoughts. They are plotting to kill you while you sleep. They are studying your carotid artery and trying to figure out the quickest way to slice it open. If I DID have a cat (I never will.) I would sleep with a towel wrapped around my neck. I should suggest this to Betty, but I suspect it would make me seem strange.

Should I have said all of this to Barry yesterday? It's better to be silent.

Now I feel like drawing. I'll draw a cat being devoured by one of my monsters. That will cheer me up, my monsters entertain me.

When I was a child, Mortimer Snerd entertained me, I thought he had a monster inside his skull. One night someone called Mortimer a blockhead. He always said, like he was saying something to be remembered by, "Snerd's Words for the Birds." That doesn't matter now. Nobody remembers who Mortimer was. And there's no reason anybody would ever remember me, even if I turned out to be a monster. Me and Mortimer Snerd. That's pretty funny. Maybe I should tell that to Barry next time he's having a smoke.

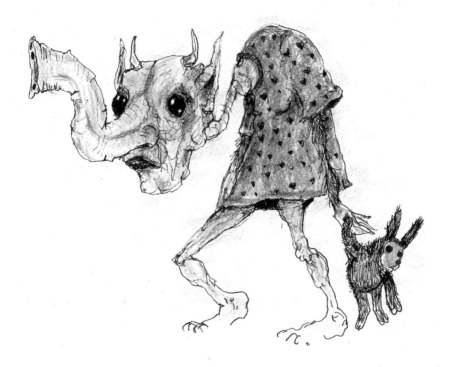

I've Never Seen an Ocean

I've never seen an ocean. In fact, the largest body of water that I've ever seen in person is Lake Ontario and that was a fleeting glance from a bus as it headed east along Lakeshore Boulevard. My podiatrist's office was near the Beaches and I had always been very prudent about my feet. Then my podiatrist died and I've had no energy to look for another one. My feet look like giant ginger roots.

But this is about the ocean. I need to focus.

My parents used to have hundreds of *National Geographic* magazines in the basement, which I would carefully sneak upstairs and away from the monsters, spending many hours flipping through them, imagining that I was travelling all over the world. Nothing fascinated me more than the photographs of oceans. Endless shades of blue and green and giant waves that swallowed up huge boats and countless sailors over the centuries. Most of all I loved to think about the creatures that lived in the very depths of those dark seas. They say that we, the whole of the human race, came out of the ocean as tiny, tiny little thingamabobs, miniscule monsters. Maybe in my drawings I am just going back into the ocean. Anyway, I imagined massive fish with gaping mouths, long yellow teeth, and bulging eyes.

Then, after that terrible tsunami in Indonesia years ago, photos of strange creatures started to appear in magazines and newspapers. Creatures that had rarely been seen before the giant tsunami washed them onto the shores.

That caused my imagination to take off. There were days I could hardly focus on my cash register, my brain seemed full of salt water and sea creatures. I made lots of mistakes on the cash register, and it's just pure luck that I didn't get fired. But those were the days when the store manager was intent on getting the bookkeeper into bed, so he wasn't paying much attention to the rest of the staff.

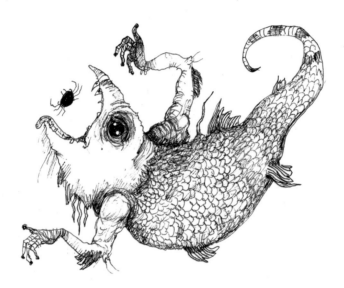

When I would come home at night after work, I could hardly wait to begin drawing the ocean creatures that I saw in my head. There were times I forgot to eat my can of beans, that's how obsessed I'd become.

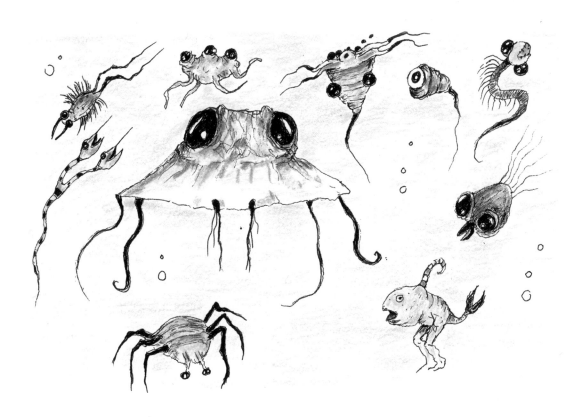

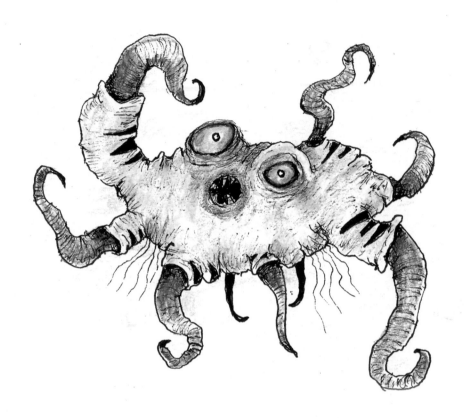

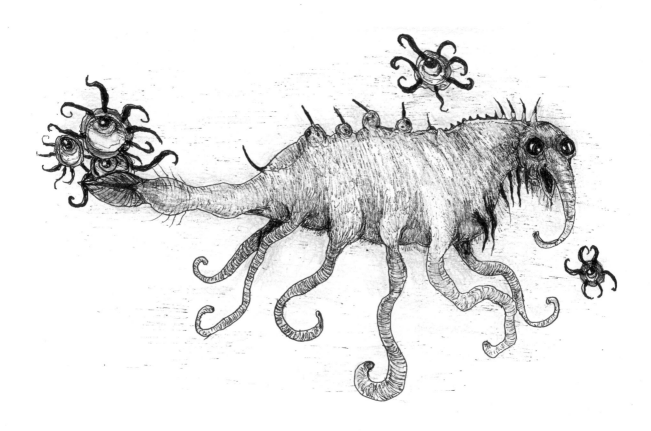

What does it feel like to swim in an ocean? I've heard that it's easy to float, because there's so much salt in sea water. But if you're floating, don't you worry about the things that might be right below you? Couldn't a jellyfish suddenly attach itself to your shoulder blades? What about sharks? Are we not just tasty morsels in their watery world? I read articles about poisonous sea urchins, fish with toxic spines, sea snakes that can paralyze you with one bite.

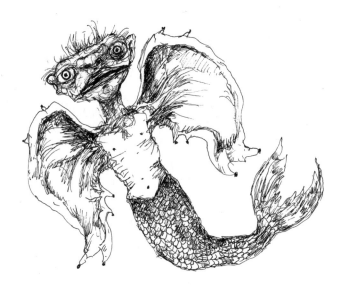

When I was a little girl, I'd go to the creek near my house, stand in murky water up to my knees, and catch tadpoles. I'd keep them in a jar until they sprouted legs. Think of it, our world in a jar, our world that's mostly ocean, full of mysteries and creatures that want to eat us?

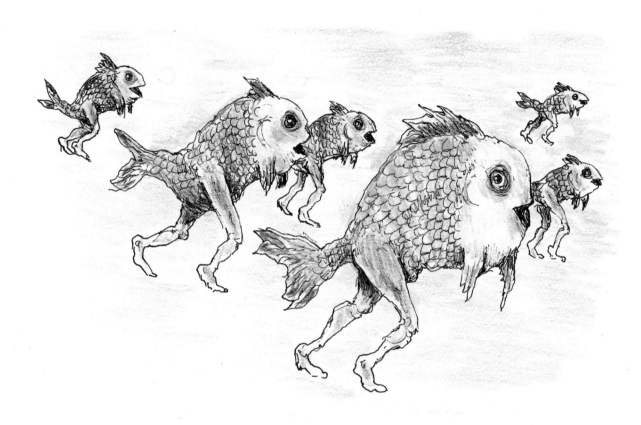

I had a customer in the store once, a mother with her little girl. The mom told me they'd been in Florida over Christmas and the daughter, who was about six years old, started to regale me with stories about jumping in the ocean waves and diving for seashells. I told the little girl that she was very brave, considering all the disgusting, slimy, evil things that were in the water, just waiting to tear her to bits and eat her. The mother grabbed the child's arm and dragged her out of the store. It bothers me that parents try to hide these things from their kids. Children should be warned about oceans. It should be mandatory on a school's teaching agenda, if you ask me.

There are several oceans, a fact that was unknown to me until I got my hands on those *National Geographics*. The North and South Atlantic Ocean, the North and South Pacific Ocean, the Arctic Ocean, Antarctic Ocean and the Indian Ocean. This means that there must be different types of creatures, because some wouldn't be able to survive in the freezing waters and others would need to adapt to warmer waters. That information quadrupled the images in my head. It was overwhelming, to be honest.

I hope to travel to an ocean someday. I have an elderly great uncle who, if he hasn't already died, lives in Miami Beach. Maybe I could visit him. I'd have to remember his name, first. I would love to step into the Atlantic Ocean just for a minute. Maybe dip my head into it, too. I'm curious about ocean water. It's briny. Like pickle juice, I think.

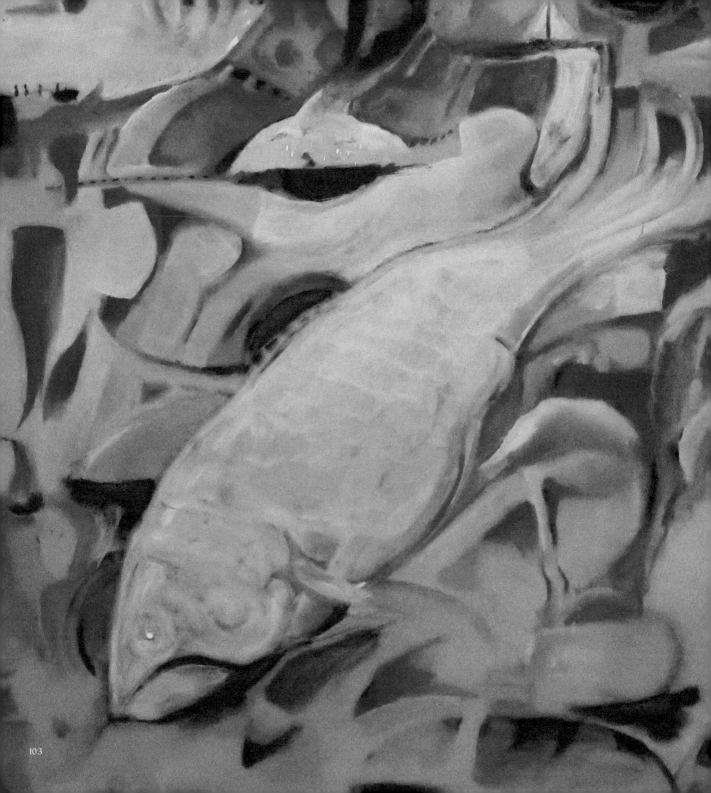

Bird Feathers

Bright red feathers, garish and flashy

Like a Las Vegas hooker.

I am not a cardinal.

Sky blue feathers

Aggressive and loud

Screaming LOOK AT ME

I am not a blue jay.

A dirty canary in winter

Come summertime

A golden doubloon.

I am not a goldfinch.

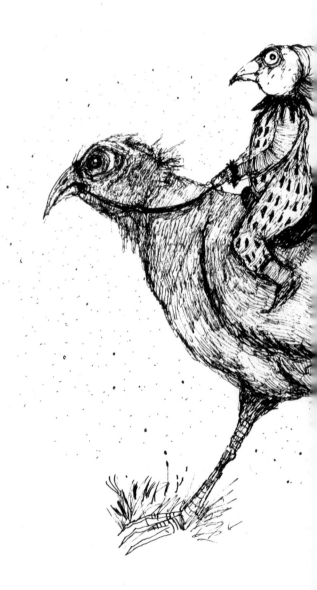

Then there is the grackle

Feathers flashing blues and purples in the light

Dull and colorless

When the sun is lost behind a cloud.

Nobody looks.

Nobody sees.

Yes, I am a grackle.

A grackle in the darkness.

Some birds hang around. Maybe I'll draw more.

The Red

I'm not easily frightened and I've never been that much of a worrier. Good health has been something I could count on my whole life, other than the usual things like colds and bunions and the occasional boil. But those are common things. I've never compared maladies with any of the people I work with, so for all I know bunions are extremely rare. I would never talk to my customers about health. They are obsessed by their own diseases. I never worry and, as far as I know, nobody's ever died from a boil.

But yesterday, while preparing my dinner (I decided to heat my beans on the stove, instead of eating them right out of the can. I felt like having a REAL meal for a change), something happened. And it was scary.

I was stirring the beans when suddenly I couldn't see. My head was pounding and everything was a bright blood red color with small black specks and shapes here and there, but mostly red.

I felt my way to my drawing chair, it's my safe place, and I plopped down in it. My heart felt as if it was going to rip itself out of my chest and I was struggling to keep from panicking.

Was I having a stroke? A brain aneurism? Should I dial 911? I decided to give myself ten minutes and if The Red didn't go away by then, I'd call for help, assuming I could find my phone. I seldom use my phone and, to be honest, I have no idea right now where it is in the house. And I have no friends to call, though there is a neighbour I never speak to, she'd be there, but would she come, and why?

I know how to stay calm, I'm very good at slowing my breathing. For years I have tested how long I can hold my breath against a watch. I almost got to 3 minutes once, distracting myself by thinking about beaches and oceans and palm trees, and if I try to imagine a beach in the Galapagos Islands, I'm good at it. And you can't panic if you're picturing tortoises in your head. So, that's what I was doing while my heart was pounding and my head was full of The Red. I was riding a tortoise. On a white sandy beach. Beside turquoise water.

I sat there, swallowed up by red and I was full of questions. Was I being swallowed up by my own blood? And for moments there seemed to be a face, a glimpse of a face, in the blood. Was this God? God of the blood? My mother had always said, "God'll get you." And if I was dying, who would find my body? Who would come to my funeral? Who would PAY for my funeral? And who would take over my cash register at FoodWorld? Would Duane miss me? I should leave him his head in my will. I'll have to make my will and put someone in it.

The Red started to slowly fade. My vision was blurry at first and everything around me was surrounded by a red haze, but soon I could make out the shapes of furniture in my living room. I could see into the kitchen and realized that the stove was still on and the beans were burning. (Would I have to throw out that pot? I love that pot. It was the pot my mother used for Kraft Dinner.)

A half hour later, I was fine again. The Red was gone. The pounding in my head was gone.

I probably should make an appointment with my doctor but he would just send me for tests. I hate hospitals and I hate being probed and prodded and how would I describe The Red to anybody anyway? If it happens again, I'll definitely call the doctor. That's what I'll do. I'll wait and see if it happens again.

On Becoming an Old Woman
(An Essay by Doris Melnick)

I was never an attractive woman, so I always thought that I'd handle aging well because I wouldn't be mourning the loss of my looks. And in some ways that's proved to be true, I can't lose something I never had. But I'm not handling aging well. Not at all. Nobody prepared me for any of this. Then again, the only thing my mother prepared me for was a life of solitude and boiled egg lunches. After that, I was on my own.

A few years ago, I was getting out of the shower when I'm pretty sure that my last egg fell out of my uterus and onto the floor. Poor little guy. It had spent years all alone inside of me, playing the old computer game Pong with my paper-thin ovaries (this would be a good drawing. I should get on it.) And then suddenly, one morning, the little guy hobbled his way to the exit and took his leave. No farewell party, no cake, no goodbye.

And that was the beginning of the end of my body as I'd known it. I started paying attention as my body began to break down. None of it's been pretty. But it's all been entertaining.

I will begin by talking about my upper arms. I first noticed them when I was at the cash register a few months ago. I was rushing because my break was about to start when I heard a flapping sound. Or maybe it was more of a slapping sound. It sounded like somebody gently applauding, but I knew that was impossible, even though I am the

FASTEST CASHIER AT FOODWORLD. And then I realized it was my upper arms, making smacking noises every time I moved quickly. I checked them out closely in the washroom during my break and I was appalled. WHOSE ARMS ARE THESE AND HOW DID I GET THEM? And why was the skin so far from the bone?

Also, I'm thinking that if my arms get any bigger, I may very well be able to levitate by flapping them hard.

Also…what is up with all the little red spots on my stomach? Where did they come from? They're not freckles and they're ugly. I have begun playing "connect the dots" with them. Last night, connecting spots, I discovered I have a portrait of Leonard Cohen on my belly.

I've been thinking some more about being an "older woman." I've always heard that delayed gratification is a good thing, something that enhances the joy of a reward. Last week I was saving a piece of cherry pie in my fridge. I planned to eat it the next day. But then I thought…what if I die during the night? A stroke. Or a heart attack. So, I gobbled that pie down before I went to bed. Delayed gratification for old people is pure cat shit.

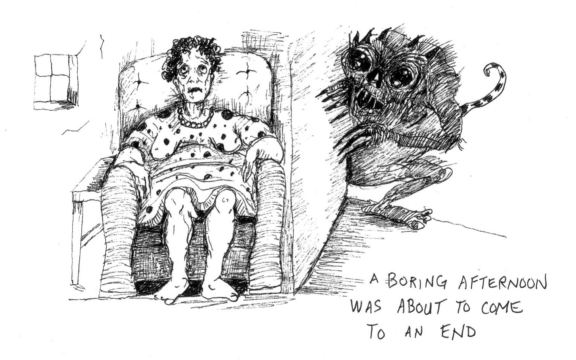

A BORING AFTERNOON
WAS ABOUT TO COME
TO AN END

As I age, I discover that I've suddenly become invisible as I move through the world. I was always under most people's radar, but I wasn't completely ignored, the way I am now. So, I've worked hard, to give a positive turn to this disappearance act. I've started stealing. I go into retail stores and when the gorgeous, 20-year old salesgirl refuses to notice me, I put something into my purse. Nothing big. A bottle of perfume or a gold necklace. A keychain with a cut crystal ball dangling from it. I like keychains. Nobody ever sees me do this. I should make some friends, because I could give them keys and they could dream about where those keys might fit.

This is not a kind world for old women. My family doctor of 40 years passed away last year and my new doctor carries on like a 15-year-old. She has a strange look in her eyes when she's examining me, as if she's seeing her future and it's making her want to throw up. My aging body, all its folds and bumps, flaps and dewlaps give her sour-faced heartburn.

So, I laugh at my upper arms and eat pie and steal the perfume and celebrate the fact that I'm still here so I can observe the craziness all around me, drawing and painting, which I'll do until they find me dead in my bed.

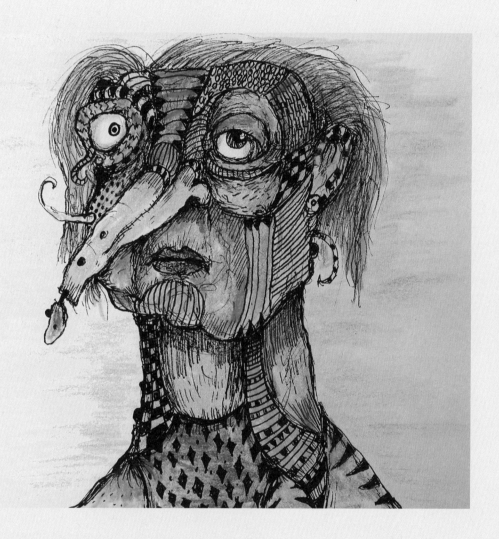

Something seems odd lately. I've been feeling strangely flat. I've caught myself making silly mistakes on my cash register. My energy seems diminished, too. Usually I'm happy to ride the bus home, it gives me an opportunity to take in all the strange faces so I can draw them later. But for the past few days, I've hardly had the strength to lift my head from the bus seat and stare. Also, I ate a banana instead of my beans. I've never eaten bananas.

I know something is wrong because I had a horrible experience with Betty in the deli department today (she ignored me at first, and then sold me stale macaroni) but I had no desire to draw her tonight. Normally a drawing of Betty being devoured alive by rabid wolverines eases my anger and gives me inner peace, but I simply wasn't in the mood to pick up my pen.

Should I be worried? Both mom and dad died when they were around my age. Should I go to the doctor? Will she want me to remove my clothes? I hate taking off my clothes. It was bad enough with my dear, dead, old doctor, but this woman-child frightens me. Will she tell me I'm obese again? The next time, I'll smack her over the head with the raccoon skull I carry in my purse. To ward off evil.

If something happens to me, what will become of my drawings and journals? And what about my HOUSE??? I need to think about these things for a while. Maybe I'll contact my parents' lawyer, if I can find his name and number. I haven't a clue where the address book is, though. It may be in the upstairs bathroom, behind the green toilet. I like hiding things behind the toilet.

I need to stop worrying. Worrying just makes me shake. I'm sure I'm fine. Breathing's a little wonky, that's all. Especially when I get angry. I seem to get angry for no reason these days. I've led a long life. I wouldn't exactly call it good, but it's been long. Duane's looking long in the tooth, and miserable. Like he sometimes hates his turnips. How do you hate turnips? I can see not wanting to eat turnips, I don't like their taste, either, kinda close cousin to heartburn's taste in my mouth. But to hate a turnip? That's not normal.

I think I'll go into the backyard and flip over the flat rocks and look for bugs. That has always calmed me when I'm stressed and anxious. It's astonishing. Year after year, there have always been new bugs. That I can count on. Bugs. After the bugs, I'll draw again. Nothing has ever aroused me, satisfied me, like my drawings. And I mean arousal as they talk about arousal in my romance novels. I'm all wound up. I won't be able to sleep until I kill Betty in a drawing.

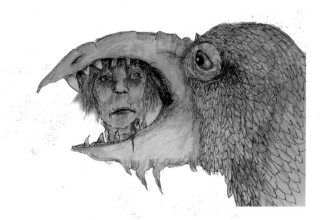

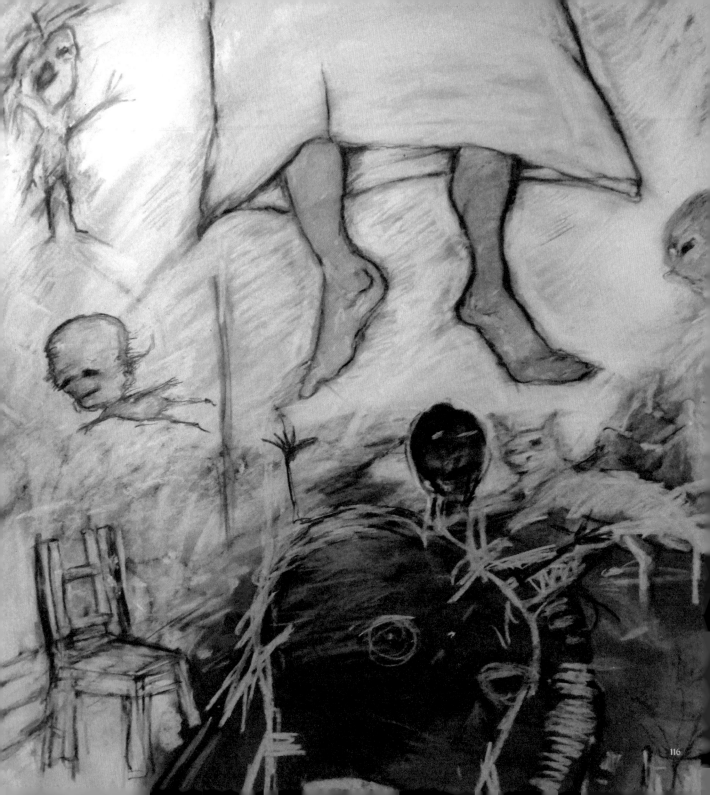

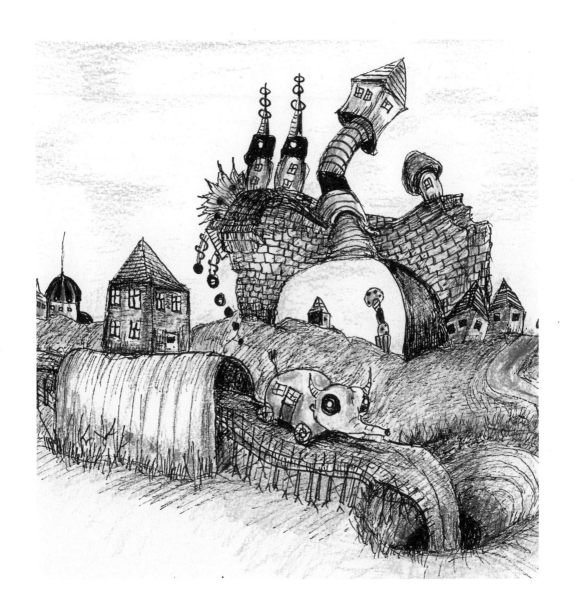

Arlene Masterson

When I heard that a book was being written about Doris Melnick, I asked if I could contribute something. I am honoured to do so, because although I didn't know Doris well in any way, I think I was closer to her than anyone in the store, in town. I regularly work cash register number four at FoodWorld, not far from Doris' station, and I used to see her every day. She seemed so isolated, so self-contained. If I tried to engage her in conversation, she'd usually flush bright red and stammer out a few words.

One Christmas, about three years ago, the management of the store took the entire staff out to the Mandarin restaurant for a Chinese buffet, and I was seated beside Doris.

We all had some wine and I suspect Doris wasn't used to alcohol. It loosened her tongue. And we talked. She confessed that she was lonely. She confessed that she thought about Duane Long, the produce manager, constantly. This wasn't surprising, I had noticed the way she looked at him. Kind of the way a dog might look at a chicken rotisserie in the window of a Portuguese restaurant. She told me that she had never had a boyfriend. I think she teared up a little.

What did surprise me was when she told me how much she loved to draw and write. She said that she had hundreds of faces and things inside her head that needed to be put down on paper, every single night. I assumed that she doodled.

She asked for my napkin, pulled out a pen from her purse and quickly sketched a head for me. She thanked me for being kind to her. I kept that napkin. Like everybody else, I was shocked to hear about her hoard of drawings. Her monsters. I wish I'd gotten to know her better.

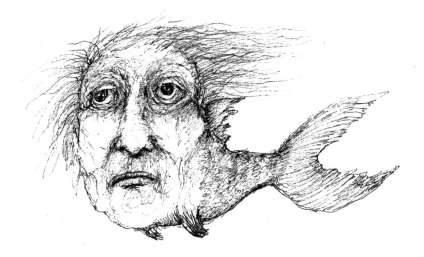

I didn't go to Doris' funeral, nobody from the store did. We weren't told anything about it and I'm not sure there ever WAS a funeral. Carol Worthington is now on cash register number one.

But here's the thing: I miss Doris, I really do. Sometimes I look up at cash register number one, expecting to see her there in her black clothes. Every day I expect to see her instead of Carol Worthington. As a matter of fact, I kind of resent Carol being there, like she doesn't belong, doesn't have the right to be where Doris was. And in a funny way, I guess she still is. There, I mean. Our Doris.

Connecting to the Darkly Comic

by Terry Graff

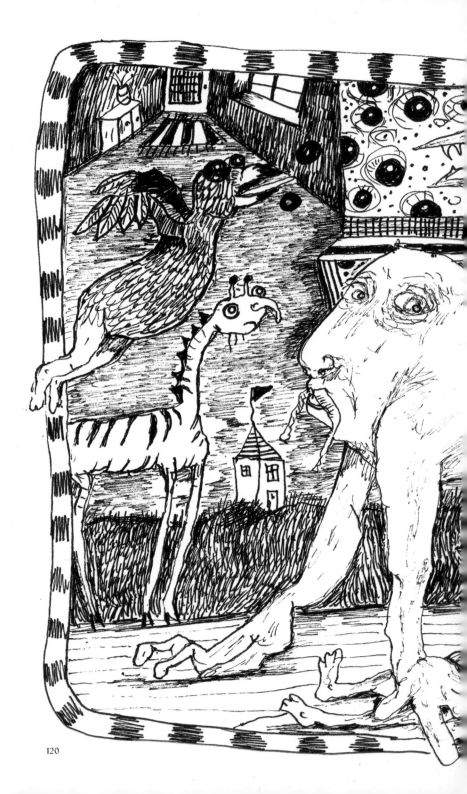

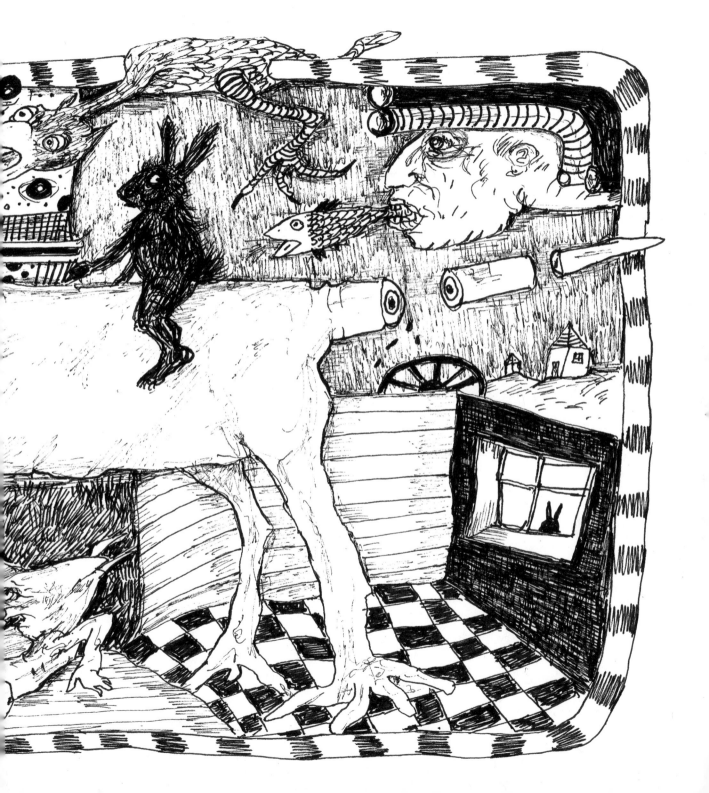

Gail Prussky is an unsettling, outlaw storyteller, in both image and word. Hers is a disquieting world of childlike whimsy and black humour, transgressive characters, and deformed misfits who awaken us to the ground-chill secrets of psychic existence. Indeed, her playful and often freakish sense of humour is a form of deep-water psychoanalytical dredging, as she pierces the shadow world of everyday life to expose hidden truths, secret lives, disturbing feelings and cravings, crushing regrets, intense angers, fantasies of aggression, bitter disappointments, horrific fears, and acute aloneness amidst the utter absurdities of existence.

Her characters, her creatures, are not general members of some jaw-clenching herd. No, they have, as she says, "their own voices, and that's because everything around me is sentient. I feel guilt when I cut up a watermelon or carrot. If I take a pill out of the bottle, I wonder if the ones I have left behind feel badly that they weren't chosen. Yes, I'm nuts."

Art can be self-therapy for the artist, or as Prussky has said, "my art has become a way of exorcising my demons, my fears, my neurosis… I tame my fears and I get them outside of me by drawing. Demons can't live in the light… I create these things so that I am their master. I control their worlds… I am not joking when I say that I would be a serial killer if I didn't draw, it's the truth. My best drawings come from my angry place, it's incredibly cathartic. I would have killed my husband years ago if I couldn't make art. Hell, even though I get older and my hands hurt more and more, get weaker and weaker, the old man thinks he's safer, he has no idea that he is still on thin ice."

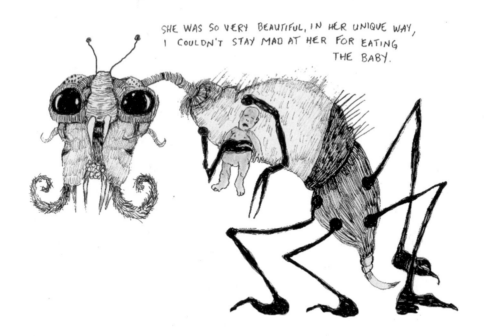

SHE WAS SO VERY BEAUTIFUL, IN HER UNIQUE WAY, I COULDN'T STAY MAD AT HER FOR EATING THE BABY.

When it comes to the study of aesthetics in art this has, in general, tended to focus on aspects of the beautiful or sublime, not on its psychologically disarming, or horrific content. Prussky's work is an ideal subject for the study of theories of horror, and the aesthetics of the fearful, particularly when viewed through the lens of Julia Kristeva's psychoanalytic theory of "abjection" and the Freudian notion of the return of the repressed.

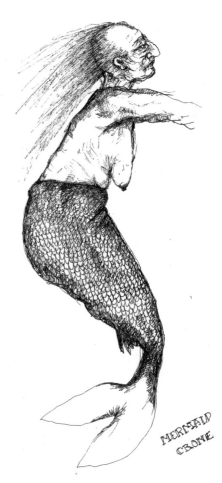

MERMAID CRONE

While sharing certain affinities with a notable group of male illustrators who also happen to be her favourite artists – Edward Gorey, Gary Larson, Ralph Steadman, and Gahan Wilson – her work also finds alignment with the "monstrous-feminine," more specifically with bodily humour and revulsion in relation to conventional ideas and behaviours about female beauty and aging.

In her personal life, Prussky will feature grotesque portraits of women she does not know as her own profile picture on Facebook. She offers them not just as stand-ins for herself, but as herself and how she is feeling at the time. "I've had friends tell me that it's cruel to put up photos of 'ugly' people, but I tell them that those women are me. I'm not making

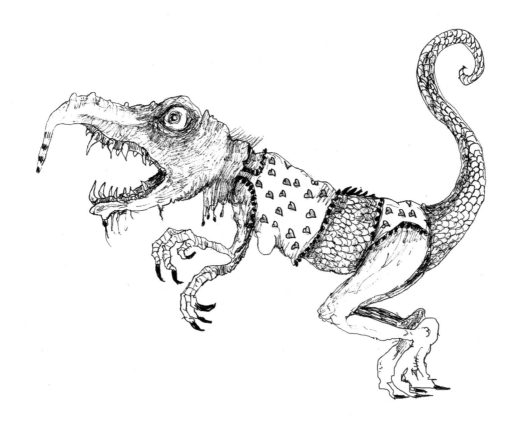

fun of them. I'm identifying with them." She goes on to say, "I think my drawings and stories are all a response to being a woman in this world, a combination of every weird thing I've seen and experienced in my life, everything I am."

Drawing was an early passion and provided a space of calm and escape for the artist as a young child, although she remembers how her Grade One teacher disapproved of a drawing she made of a green and purple human figure. "My teacher was unhappy with it, explaining that people weren't green and purple. She shut down my creativity for a long time. I think lots of teachers do this."

As an adult, Prussky earned a degree in Fine Arts at York University, and later, also a degree in addiction therapy at George Brown College. "I was then hired by Donwood Institute where I worked with cocaine and crack addicts. I did that for 10 years and was wonderful at it for nine. I was burned out at the end and the clients were too smart to fool, so I quit. Over those 10 years, I heard lots of horror stories that no doubt affected my art."

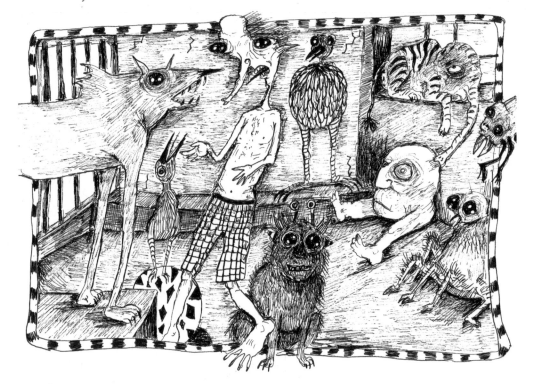

Prussky has created thousands of drawings, most of which are stored in binders. She doesn't have a regular routine for working, but draws "when the urge hits," which is almost every day. Usually a drawing is done in one sitting and takes anywhere from

15 minutes to an hour, depending on the level of detail. She prefers drawing over painting. "I don't usually enjoy painting. It's hard work for me and can be frustrating and enraging. I have to force myself to paint. But drawing is a different story. I love drawing. Drawing flows out of me and brings me joy."

Prussky never thinks about what she's going to draw. "It just happens. If I try to draw something specific, I choke. With a simple sketchbook and always a Staedtler pigment liner, a 0.3, I just begin and it goes where it goes. I'm pretty sure there's some sort of magic put into these pens back at the factory because strange things come out of them. If I want colour in a drawing, I use coloured pencils. After I've drawn something, I look at the image and think of the text for it. My stories are created the same way. It seems that most artists like to think about what they're going to create before they start. I'm happy with the way I work, because it all comes from a place that has no language. It's incredibly satisfying."

Prussky doesn't know where her fictional character Doris Melnick came from.

"I bolted up in bed at 2 a.m. one night and invented her."

However, as she confesses, along with sharing her love of drawing and writing, "there is a lot of Doris in me. Some of my journal writings are based on my own experiences, such as the racetrack story; and my ruminations about becoming an older woman are very much my own. My mother, however, was not abusive like Doris' mother. I just needed to come up with a reason to put monsters in the basement. I used to have recurring dreams about things in the basement, mostly giant aquariums that contained gross, slimy sea creatures and overgrown fungus, things that had been neglected but still thrived, all moldy and disgusting. I identify with Doris because she is a character

whose inside doesn't match her outside. I was that kind of person for many years, never sharing my art or the weird things inside my head. Obviously, that's changed. Since I've 'flown my freak flag' I am happier and healthier than I was when I was a young woman."

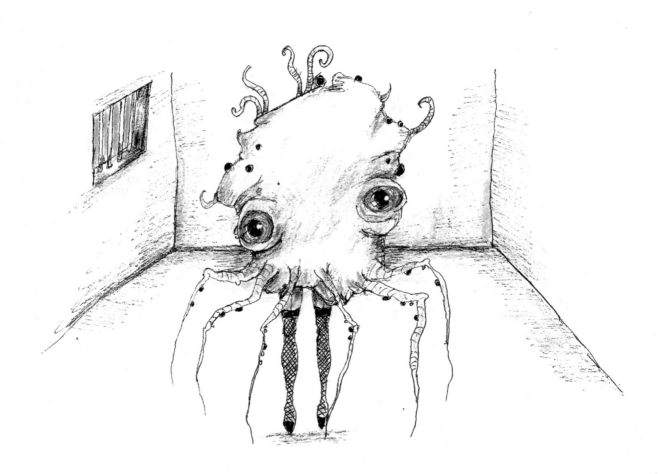

It's well-known that humour reduces stress by slowing the heart rate, by lowering blood pressure, and improving oxygen consumption. Further, a 2017 psychological study at the Medical University of Vienna determined that an appreciation for dark laughter can be linked to high levels of intelligence, emotional stability, and low levels of aggression. If true, then lovers of Prussky's world, of her Doris, must be singularly healthy in their heads – and very intelligent heads they must be.

The real mystery of Prussky's work, however, is more elusive. It lies in this question: How has the utterly grotesque, the totally abnormal Doris, come to be in our minds utterly normal… that is, why – after only a few stories and a sheaf full of drawings – do we feel so intimately the pathos of her life? Why do we feel a oneness with her, with her sudden realization that she is growing old? Why do we so closely feel her heartbreak as she reads her signs – upper arms flapping like fleshy wings; fuelled by hard-boiled eggs and beans – those signs, through her, becoming our signs, to be read and seen as incoming death?

That is the mystery of the short unhappy life of Doris Melnick, but that is also the triumph: How did Prussky, through such an unlikely cast of characters, through such a faceless non-entity as Doris, get us to identify with the gal, so that we feel – as one of her fellow workers remarks at the end – that she is one of us, and so we are one with her? That's a trick that every storyteller, writer, or painter, dreams of bringing off.

ACKNOWLEDGEMENTS

Huge thanks to Michael and Barry Callaghan, who whipped this old crone into shape again and again. Without their guidance and perseverance, Doris Melnick wouldn't have existed. I am also grateful to have been a part of the emerging writers mentoring program offered by The Excelsis Group. And thanks always to Alan, who tolerates my bizarre world with smiles and headshakes. All the time. And to Carolyn, the angel who hovers above me when I'm trying to create. I love you and miss you.

Gail Prussky is an ex-addiction therapist who moved from Toronto to rural Ontario in 2007. In this slowed-down setting, it suddenly occurred to her that if she didn't write and make art (a new-found passion), she'd probably become a serial killer. Taking this into consideration, she owes much of her creative side to her desire to never experience incarceration. The fact that many people enjoy her work has been a bonus. Gail's art has been exhibited in numerous solo and group shows, and is in collections around the world.

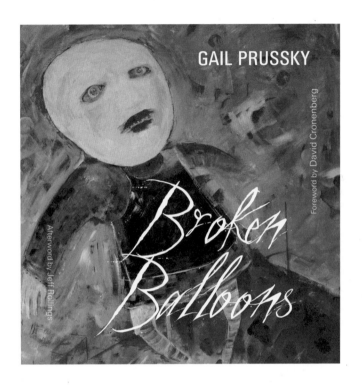

Beautifully drawn and painted, accompanied by stories and poems, Gail Prussky's first book is a wonderful menagerie of insects, animals, and people – startling, at times frightening, but always grin-inducing over the pages. These 54 black-and-white and 16 colour works of art see the artist-author take her place alongside Edward Gorey, Ralph Steadman, Gary Larson, Robert Crumb and Maurice Sendak. Foreword by auteur David Cronenberg.

8 x 8.25 Paperback 978-1-55096-545-2 $19.95